BLACKPOOL PUBS

ALLAN WOOD & CHRIS BOTTOMLEY

AMBERLEY

Dedicated to the lads – past and present.

First published 2016

Amberley Publishing
The Hill, Stroud
Gloucestershire, GL5 4EP

www.amberley-books.com

Copyright © Allan Wood & Chris Bottomley, 2016

The right of Allan Wood & Chris Bottomley to be identified as the Authors of this work has been asserted in accordance with the Copyrights, Designs and Patents Act 1988.

ISBN 978 1 4456 5283 2 (print)
ISBN 978 1 4456 5284 9 (ebook)

All rights reserved. No part of this book may be reprinted or reproduced or utilised in any form or by any electronic, mechanical or other means, now known or hereafter invented, including photocopying and recording, or in any information storage or retrieval system, without the permission in writing from the Publishers.

British Library Cataloguing in Publication Data.
A catalogue record for this book is available from the British Library.

Origination by Amberley Publishing.
Printed in the UK.

Contents

	List of Pubs	4
	Introduction	8
Section 1	Blackpool's Early Days	9
Section 2	'Lost' Pubs (North to South Listing)	19
Section 3	The Town Centre	36
Section 4	Talbot Road – from The Layton	51
Section 5	Central and South Shore	62
Section 6	Around Blackpool	80
	Sources and Acknowledgements	96

List of Pubs

Section 1: Blackpool's Early Days
Forshaw's Hotel, Talbot Square (later the Clifton Arms Hotel, now Ibis Styles Hotel)
Bailey's Hotel, Promenade (later Dickson's, now the Grand Metropole)
The County and Lane Ends, Church Street/Promenade
Hull's Tavern, Promenade (now the site of The Albert and The Lion)
Bonny's i'th Fields (now the site of the King Edward VII, Central Drive)
Yorkshire House, Promenade (just north of Yorkshire Street)
Red Lion, Devonshire Road, Bispham
Gynn Inn, Gynn Square (on the site of Gynn Square roundabout)
No. 4 and Freemasons, Newton Drive, (originally the Eagle Nest)
No. 3, Devonshire Square (also the No. 3 and Didsbury)
Saddle Inn, No. 286 Whitegate Drive, Marton
The Shovels, No. 260 Common Edge Road, Marton

Section 2: 'Lost' Pubs
Anchorsholme Hotel, No. 4 Anchorsholme Lane (later the New Anchor)
Mariners, No. 8 Norbreck Road
Uncle Tom's Cabin (on the edge of the cliffs)
Dickson Bar, Dickson Road
Empress Hotel, No. 59 Exchange Street, North Shore
Brewers Arms, Cocker Square (Fumbler's Hill)
Derby Arms Hotel, Cocker Square (now Liberty's Hotel)
Windmill Hotel, Hoo Hill, Layton (formerly the Mill Inn)
The Dinmore, Dinmore Avenue, Grange Park
Grosvenor, Cookson Street
Wheatsheaf, No. 196 Talbot Road
Kings Arms, No. 172 Talbot Road (also named the Flying Handbag)
Talbot Hotel, Talbot Road
Yates's Wine Lodge, Talbot Square
The Mint, Nos 22–28 Clifton Street (formerly Martins Bank)
Adelphi Hotel, Church Street
Market Inn/Market Hotel, Lytham Street (now Corporation Street, BHS site)
Oddfellows Arms, No. 4 Euston Street (BHS site)
The Fleece, No. 27 Market Street (later NTK, Ego Bar, Brannigans)
The Castle Inn, Market Street (BHS site)
The Albion Hotel, Promenade and Church Street (north side)
The Little Vic, Victoria Street (formerly the Victoria Vaults/Inn)

Beach Hotel, Promenade (north end of the Tower Building)
Tower Lounge, Nos 41–43 Bank Hey Street (now Harry Ramsden's)
Welcome Inn, No. 40 Bank Hey Street
The White Swan Hotel, Nos 46–48 Bank Hey Street (now partly the Under Bar)
The Clarence and Railway Hotel (site of Moda Italia)
The Palatine Hotel, Promenade, Hounds Hill
The New Inn and Central Hotel, Promenade, Hounds Hill
The Railway Inn, No. 5 Bonny Street
Our House, Nos 2–4 Oddfellow Street
The Victoria Hotel, Central Promenade
The Concert Inn, No. 64 Bonny Street
Wylie's South Pier Hotel, Promenade adjacent Chapel Street
Farmer's Arms, No. 7 Chapel Street
The Wellington and Pier Hotel, Chapel Street and the Promenade
Prince of Wales, Nos 10–12 York Street (later the Gauntlet, Jaggy Thistle)
Atlantic Hotel, Foxhall Road
Bay Horse Inn, Lytham Road
The Exchange Wine Bar, Nos 98–100 Bolton Street (later The Brigadier Gerard)
Bird in Hand, Bolton Street
Bowling Green Inn, Bath Street and Waterloo Road
Waterloo Tavern, Cow Gap Lane (Waterloo Road)
Lord Nelson, Preston Old Road
The Oxford, Oxford Square, Marton (formerly the Mill Inn)
Cherry Tree Gardens Hotel, Cherry Tree Road (also Your Father's Mustache)
The Royal, Marton Drive (now a Tesco Express)
The Grand Hotel, Station Road
Flannagans, Nos 495–497 Promenade, corner of Station Road
Star Inn, on the foreshore south of the Pleasure Beach

Section 3: The Town Centre
Kings Bar, No. 103 High Street (formerly The Mount Pleasant)
Peek-a-Booze, Nos 72–74 Dickson Road
Casey's Bar, Nos 68–70 Dickson Road
Duke of York, No. 60 Dickson Road
Man Bar, No. 23 Dickson Road (formerly Taboo, Kitty's Showbar)
R Bar, No. 1 Lord Street
Kaos, Nos 38–42 Queen Street
The Flying Handbag, No. 44 Queen Street
Buckinghams Bar, No. 35 Queen Street
Roxy's, No. 23 Queen Street
Bar 19, No. 19 Queen Street
The Litten Tree, Nos 8–14 Queen Street
Walkabout, Nos 1–9 Queen Street
Nellie Deans, Nos 150–152 Promenade
Galleon Bar, Nos 68–70 Abingdon Street
Ned Kelly's, Nos 19–23 Clifton Street (formerly Copacabana)
The Hop, Nos 2–4 King Street (formerly Veevers Arms)
The Blue Room, No. 139 Church Street (also the Stanley Arms Hotel)

Frenchman's Cove, No. 15 South King Street
The Townsman, No. 96 Topping Street
Gillespies, Nos 87–89 Topping Street (formerly the Shakespeare Hotel)
Churchills, Nos 83–85 Topping Street (formerly the Criterion
Cedar Tavern, No. 15 Cedar Square
The Washington, Topping Street
Rose and Crown, Nos 22–24 Corporation Street
Scruffy Murphys, No. 32 Corporation Street (formerly The Grapes)
Yates, No. 100 Promenade and Nos 13–15 Market Street
Shenanigans, Nos 98–100 Promenade
The Layton Rakes, Nos 17–25 Market Street
The Mitre, No. 3 West Street
Brannigans, No. 27 Market Street
Revolution, No. 35 Market Street
The Albert and The Lion, Bank Hey Street

Section 4: Talbot Road
The Layton, No. 30 Westcliffe Drive (formerly Layton Institute)
The Queens, No. 271 Talbot Road
New Road Inn, No. 242 Talbot Road
Ramsden Arms Hotel, No. 204 Talbot Road (originally the Golden Lion)
Wheatsheaf, Nos 194-196 Talbot Road
Kings Arms, Nos 170–172 Talbot Road (was also named the Flying Handbag)
Talbot Hotel, Talbot Road
Ma Kellys, No. 77 Talbot Road (formerly The Station)
The Imperial, Nos 69–71 Talbot Road (also Flashmans, Tobago and Taboo)
Pepes Bar, No. 94 Talbot Road
The Victoria (Whittle Springs), No. 50 Talbot Road
Molloy's, No. 23 Talbot Road (originally The Railway, later O'Neill's)
Yates's Wine Lodge, Talbot Square
Nyx Bar, No. 11 Talbot Road, (formerly Jenkinson's, Rumours)
Clifton Hotel, Talbot Square
Counting House, No. 10 Talbot Square (formerly a Midland Bank)
Merrie England, North Pier

Section 5: Central and South Shore
The Castle, Nos 28–32 Central Drive
Pump & Truncheon, No. 13 Bonny Street (formerly the Brunswick Hotel)
Bierkeller, No. 93 Promenade (formerly the Trocadero, also the Huntsman)
The Stanley, Nos 9–11 Chapel Street
King Edward VII, No. 39 Central Drive
The George Hotel, No. 174 Central Drive (on the site of the Revoe Inn)
Uncle Peter Websters, No. 123 Promenade (formerly the Washington)
The Ardwick, No. 32 Foxhall Road
Lifeboat Inn, No. 58 Foxhall Road
Ma Kellys Central, No. 62 Foxhall Road (formerly The Princess Hotel)
MacNaughtons Bar, Nos 64–66 Foxhall Road
The Foxhall, Nos 193–197 Promenade

Crazy Scots Sports Bar, No. 45 Tyldesley Road
The Manchester Bar, Nos 231–233 Promenade
Old Bridge House, No. 124 Lytham Road
The Excelsior, Nos 177–181 Lytham Road
The New Albert, No. 215 Lytham Road
Auctioneer, Nos 235–237 Lytham Road
Ma Kellys South, Nos 239–241 Lytham Road
Dog and Partridge, No. 265 Lytham Road
Royal Oak, No. 322 Lytham Road
Yates, Nos 407–411 Promenade (formerly the Lion)
The Sun Inn, No. 88 Bolton Street
The Dutton Arms, South Promenade (site of the Commercial Hotel)
The Bull, No. 17 Waterloo Road
The Harold, No. 46 Bond Street (also the Old Bank Inn, Last Orders)
Velvet Coaster, Nos 501–507 New South Promenade
Star, No. 525 Promenade (the Seven Stars, later the Apple and Parrot)
Burlington Hotel, No. 449 Lytham Road
Farmers Arms, No. 570 Lytham Road
Dunes Hotel, No. 561 Lytham Road (formerly The Coffee House Inn)

Section 6: Around Blackpool
The Golden Eagle, Warren Drive ('Thornton Cleveleys')
The Albion, No. 226 Red Bank Road, Bispham (formerly The Old England)
Xanders Bistro & Bar, Nos 204–206 Red Bank Road
Bispham Hotel, No. 68 Red Bank Road
The Highlands, No. 206 Queens Promenade, Bispham
The Squirrel, Bispham Road
Uncle Tom's Cabin, Queen's Promenade
The Gynn, Dickson Road (on the site of the Duke of Cambridge)
Devonshire Arms, Devonshire Road
Last Orders, No. 80 Sherbourne Road (formerly The Sherbourne Arms)
The Victory, Nos 105–107 Caunce Street
Raikes Hall Hotel, Liverpool Road
Belle Vue, Whitegate Drive
Boars Head, No. 38 Preston Old Road
Mere Park Hotel, Preston Old Road
The Clarence, No. 88 Preston New Road
Toby Carvery, Preston New Road, Marton (formerly the Clifton Arms)
The Outside Inn, Hallam Way, Whitehills Business Park
The Swift Hound, Rigby Road
The Cherry Tree, No. 319 Vicarage Lane (formerly the Welcome Inn)
Lane Ends, No. 57 Hawes Side Lane
Bloomfield Brewhouse, No. 47 Ansdell Road
The Waterloo, Waterloo Road
Brewer's Fayre, Yeadon Way (formerly The Yeadon Way)
The Highfield, Highfield Road
The Halfway House, St Annes Road
Air Balloon, Squires Gate Lane

Introduction

Although Blackpool's origins can be traced back to 1602, it did not become known as a place to visit to 'drink the waters' or 'take the air' until the mid-1700s and after that it grew slowly through the eighteenth and early part of the nineteenth centuries, eventually subsuming the surrounding villages of Bispham with Norbreck, Layton with Warbreck and Marton.

This book, to our knowledge, is the first that seeks to collate and record details of Blackpool's pubs and most well-known licensed premises. It takes the modern boundary of Blackpool as its catchment area for the pubs and licensed premises it includes.

Blackpool's licensed premises were initially places that primarily provided accommodation and this book inherently crosses boundaries into what are hotel-based establishments and licensed premises that are more properly bars. It does not attempt to detail all of the various small bars, nightclubs or working men's clubs there are around the town. Pubs on street corners are not the norm in Blackpool and while it has one of the highest densities of licensed premises outside the West End of London, there are very few old pubs, even fewer that have retained any of their original character and many that have been lost to redevelopment. Another unusual aspect of Blackpool pubs is the number that have changed their names over the years.

Blackpool has thrived in the past on the facilities and freedoms people have in the town to enjoy themselves, including drinking, and this remains a major part of the attraction for Blackpool's visitors. However, it is also the case that Blackpool, today, suffers disproportionately when compared to the wider UK population from alcohol-related harm and crime. The purpose of the book is not to glamorise or extol pubs but to record a part of Blackpool's social history that has not previously been collated.

The book contains six sections with photographs of the pubs as they once were in some cases and as they are now in others. Section 1 sets out Blackpool's earliest known licensees and details of the principal places of accommodation in the developing seafront section of the town in the eighteenth century, together with details of the older alehouses and inns serving the local community in the surrounding village areas. Section 1 also includes a short section on Blackpool breweries and a note regarding Blackpool Fylde & Wyre CAMRA.

Section 2 lists the numerous pubs that have been 'lost' or closed over the years. Section 3 deals with the town centre pubs and Section 4 covers Talbot Road, although we start from what was Layton Institute (now The Layton) on Westcliffe Drive. In Section 5 we cover Central and South Shore, starting at the north end of Central Drive. Section 6 deals with all the other outlying pubs from the Golden Eagle on Warren Drive at Anchorsholme, to the Halfway House at the Squires Gate Lane. We hope this book entices you into one or two different ones.

Section 1

Blackpool's Early Days

The earliest historical records relating to the licensing of premises in what is now Blackpool are the 1722 Alehouse Recognizance records which, though difficult to read, list two persons as innkeepers in the manor of Layton, one being an E. Butcher. The September 1739 records list the following as licensed persons residing in the manor of Bispham: John Fisher and Edward Roo (not listed in 1740), in Layton with Warbreck; Robert Whiteside and James Dobson and in Marton; Thomas Whiteside, Thomas Dobson, James Dobson and Elizabeth Parkinson (a widow).

Most commonly quoted as the first licensees granted to residents of Blackpool are the four persons listed in the 1755 Alehouse Recognizance records. This is probably because the place of residence recorded in the 1755 document, for four licenced innkeepers, is 'Blackpool'. These being: John Hebson (Bonny's at the east end of Chapel Street, now the site of the King Edward VII pub), John Forshaw (Forshaw's Hotel – later the Clifton Arms Hotel, Talbot Square), Thomas Gaulter and Richard Hodgkinson (Elston's, later Yorkshire House). The 1756 document (and later records) do not give the places the four licensees lived as Blackpool, as at that time Blackpool was a hamlet within the township of Layton with Warbreck but states them as being residents of Layton for three of them and the fourth (Thomas Gaulter) is not listed at all.

In addition to the four 'Blackpool' licensees included in the 1755 Alehouse Recognizance records, it states that the licensees then residing in Bispham were: John Fisher, Thomas Broadbelt, John Tinkler (of Tiddicar) and Richard Danson; in Layton, Robert Whiteside (No. 4); and in Marton, Edward Bamber, John Butcher (thought to be of Revoe) and Thomas Hill.

In the mid- to late 1700s, Blackpool was slowly developing along the seafront between Fumbler's Hill (now Cocker Square) and Foxhall (Princess Street). Along here, places of accommodation/hotels were erected for the increasing number of visitors and these were licensed to sell beer, wine and spirits. The principal places were Forshaw's Hotel (later the Clifton Arms Hotel); Bailey's Hotel (later the Metropole); The Lane Ends; and Hull's Tavern (later the Royal Hotel, Bonny's and Yorkshire House).

In the surrounding areas as we know them today, Bispham, Layton and Marton, the alehouses/inns serving the local community included: the Red Lion; Bispham; the Gynn Inn, Eagle Nest – later the No. 4; the No. 3 at Devonshire Square; the Saddle Inn at Great Marton and the Shovels at Great Marton Moss. These 'early' licensed premises are described in the following section.

Blackpool in 1784.

Forshaw's Hotel, Talbot Square (later the Clifton Arms Hotel, now Ibis Styles Hotel; 1760s–present)

Forshaw's Hotel, built in the 1760s in what was then Belle Vue Square, was one of Blackpool's earliest lodging places. Thomas Forshaw took over the running of the hotel around 1769 from his brother John. It was later known as Nickson's Hotel after Cuthbert 'Cuddy' Nickson and was sold to Thomas Clifton in 1832. The hotel was the location for a dinner with over 150 guests on the opening night of North Pier on 21 May 1863. The Clifton Arms and Pier Hotel Company Ltd acquired the hotel in November 1864 and in the period 1865–74 it was reconstructed and replaced by the three-storey Clifton Hotel we see today. In 1875 the owner was John Talbot Clifton and the hotel was purchased in August 1876 by the Clifton Arms Hotel Co., Lytham Ltd. The Talbot Square location, opposite North Pier, is one of the most prestigious locations in the town and the public bar on the Market Street corner of the building has had many names over the years. In the 1960s and '70s it was the famous (and lively) 'Scotch Bar', popular with Scots on their annual holidays. From 1975, for a period, it was the Clifton Ale House with an entrance on Market Street and with the Captain's Cabin downstairs and later it was the Clifton Corner Bar. In December 2008 it became the Che Bar and was linked with the basement CoCo Nightclub. The Che Bar closed in 2015 and the corner site of what is now the Ibis Styles Hotel is closed.

Bailey's Hotel, Promenade (now the Grand Metropole; c. 1784–present)

Bailey's was built and opened by Lawrence Bailey c. 1784 with three dining rooms, a coffee lounge, thirty-four bedrooms and a bathing machine available 'for his friends'. It was for many years the most northerly hotel on the Promenade and remains the only hotel on the west side of the tram tracks. In 1826, the hotel was purchased by Robert Dickson and was renamed the Higher Royal Hotel. In 1852 it became Rossall's Dickson Hotel after being taken over by Robert Rossall, then soon afterwards (at least by 1867) it reverted to the name Bailey's when it was owned by William Bailey. It was bought by Metropole Hotel Ltd in August 1893 and was requisitioned by the government between 1939 and 1947. The Metropole Hotel was owned by Butlins between April 1955 and 1998 and later became the Grand Metropole. Grand Hotels sold the hotel to Britannia Hotels in 2004.

The Metropole c. 1905.

The Lane Ends, Promenade and Church Street, south side (established c. 1760, later the County & Lane Ends, then the County, demolished 1961)

The lower part of what is now Church Street, at the Promenade, was known as Lane Ends in the eighteenth century. It was the place where the old coaching road from Preston via the No. 3 in Layton ended at the sea and where a cluster of properties, including Lane Ends House, were built. In *A Description of Blackpool, in Lancashire: Frequented for Sea Bathing* (1789), Hutton suggests that Lanes End House was a place where visitors could take refreshment as early as 1761. The Lane Ends Hotel was sold by John Bamber to Thomas Lewtas in the early 1770s.

In an advert in the *Manchester Mercury* of 25 March 1788, Thomas informs us that he has 'declined' the Inn in favour of John Hudson, 'the late waiter at the Hall in Buxton.' Henry Banks purchased the Lane Ends Hotel in 1819. It was demolished in 1864 and rebuilt as the County & Lane Ends Hotel and opened in the summer of 1865. In April 1919, W. H. Orry (ladies' and gentlemen's outfitter) opened in premises on the Church Street/Bank Hey Street corner of the hotel which was previously the 'Vaults' and is now the site of a mobile phone shop. In 1927, the hotel was extended and another storey added to provide 100 bedrooms. It was demolished in 1961, at the same time as the adjoining Palace Theatre, for Lewis' store. Lewis' was closed on 9 January 1993 and in turn was partly demolished, with two storeys removed and the distinctive blue tile and honeycomb cladding being replaced by a red brick façade, which housed Woolworths on part of the ground floor until December 2008. Harry Ramsden's Fish Restaurant occupied the Church Street/Promenade corner site of the 'Lane Ends Hotel' for many years until July 2016.

Hull's Tavern, Adelaide Place (later The Royal Hotel; c. 1780–1935)

In the 1780s, a thatched property on this site was known as Mr Hull's Tavern, catering for visitors to Blackpool. It was named after its owner Edward Hull (a local farmer) and was later referred to as the Houndshill Hotel. In 1824 it became Gaskell's Hotel, in 1828 Fish's Hotel and from the 1830s it was known variously as the Commercial Hotel, Simpson's Royal Hotel (after its owner from 1839, Mr J. Simpson), Brewer's Royal Hotel and Gaskell's Royal Hotel. The Royal Hotel remained largely as built until it was demolished in 1935 for Woolworth's department store, which was completed in 1938. Woolworth's closed in 1984. The ground floor is now largely occupied by the Albert & the Lion.

The Lane Ends Vaults from around 1895.

Bonny's i'th Fields, Chapel Street (c. 1780–1902)

From Norman Cunliffe's research, it is known that William Bamber purchased land in Layton and Bispham in 1576 from Thomas Fleetwood and that the Bamber farm stood in the 'Lower Blackpool' area of the present King Edward VII Hotel, on what was later known as Bonny's Lane (now Chapel Street). The farm was subsequently occupied by John and Margaret Hebson, who ran both the farm and a beerhouse and later a seasonal accommodation house, known as 'Old Margery's', until her death in 1767. Robert Bickerstaffe (nephew of John Hebson) later ran the business on behalf of his daughter Jenny and in May 1785 she married John Bonny. Shortly after, the property became Bonny's and was enlarged and run by John Bonny until 1819 and later by his eldest son William until around 1838. The farm and the inn were demolished in 1902 and Great Marton Road (Central Drive) and the King Edward VII Hotel were built.

Yorkshire House (formerly Elstons), Promenade (c. 1790–1875)

The property that became Elstons accommodation house c. 1788 stood on a promontory to the west of the road at that time, (it could not then be called a promenade), between Chapel Street and the Foxhall Hotel. At that time, coach parties from Yorkshire and especially Halifax were regularly making the twelve-hour journey to Blackpool. By the late 1790s the accommodation house became known as Yorkshire House.

Red Lion, Devonshire Road, Bispham (c. 1790–1939 to present)

A public house on this site dates from the late 1790s and was situated on Church Road (now All Hallows Road) abutting the road. Around 1814 it was upgraded to accommodate boarders and became known as the Red Lion. In May 1893, when J. Swain was the tenant, a bowling green to the west of the hotel was opened. In December 1894, after the Norwegian barque *Abana* was wrecked off the coast at Little Bispham, the crew were brought to the Red Lion to recuperate over Christmas. The pub was later owned by J. W. Lees & Co. of Greengate Brewery Middleton Junction and they sold it to Dutton's Blackburn Brewery Ltd in 1937.

Red Lion.

The Red Lion on All Hallows Road (shown in the photograph) was closed on 17 July 1939 and a new pub opened on the adjacent site facing Devonshire Road, designed on Georgian lines in red brick with a green slate roof and with a modernist interior. The main entrance had a revolving door into the hall with marble walls and a mosaic floor. For many years it was a Whitbread 'Beefeater' pub and is now primarily a Beefeater restaurant with a Premier Inn hotel attached.

Gynn Inn, Gynn Square (1850s–2 May 1921)

Commonly considered to have been one of Blackpool's oldest lodging houses, the farmhouse and outbuildings of Gynn Farm were built around 1740 near to the sea at Gynn Square on what is now the site of the roundabout. It remained a farm, taking in the seasonal visitors until the early 1830s when, due to financial problems, the building was turned into a grocers and beerhouse, becoming a public house in the 1850s. The whitewashed cobblestone walled building, with 'GYNN INN' painted in large black letters on the west facing side and south facing front, was a popular subject of postcards in the early part of the twentieth century. While there were protests at its closing on 2 May 1921, the *Gazette* of 3 May 1921 said that 'its disappearance will be accompanied by few regrets'. Granny Alice Ashworth, who was the last landlady and had been the licensee for over twenty-five years, moved to the Uncle Tom's Cabin pub just up the road, which was managed by her daughter Mary Burnett. The pub was demolished in August 1921 to make way for new road and tramway extensions planned after the incorporation of Bispham into the borough of Blackpool.

No. 4 and Freemasons (formerly Eagle Nest), Newton Drive (c. 1730–present)

The 1739–55 Alehouse Recognizance Rolls records a Robert Whiteside of Layton with Warbreck as an innkeeper. In his 1980 booklet *Layton Village*, Alan Stott states that 'Robert Whiteside was almost certainly licensee of a house which developed in Layton itself, which tradition says was called The Eagle Nest but became known as the Freemasons or No. 4'. The building that became the Eagle Nest was a cottage near the corner of Layton Lane (then the main route from Poulton to Blackpool) and Dykes Lane (later Newton Drive). It was owned by the Banks family of Layton and it appears that by the 1730s the cottage was being run as a beerhouse. The earliest recorded date for the Eagle Nest being renamed the No. 4 is 1824. In 1872, when the records state the pub was owned by Lawrence Banks and Robert Bibby, the licensee was Samuel Bamber,

Gynn Inn.

who had been a mason since 1863 and was to become Hesketh Lodge's first Worshipful Master. The new No. 4 and Freemasons public house, on the corner of Layton Road and Newton Drive, was built in approximately 1891–92 and incorporated the old buildings of what was the Eagle Nest. The origins of the pub's name 'Freemasons' relates to the first local meeting of that group, which was held at the original pub. By 1889 the pub had been sold to Henry Shaw and Co. of Blackburn and was occupied by William Kershaw from around 1896. The pub is now owned by Thwaites and has a central bar with a lounge and separate games room with a pool table at the rear. Unusually, it has squash courts in the adjoining building, which were built in around 1981.

The No. 3 and Didsbury, No. 3 Devonshire Square (c. 1730–present)

The No. 3 dates from the early eighteenth century. Lawrence Fish is recorded as being at the No. 3 in 1824. The property was conveyed to the Raikes Hall Park Gardens and Aquarium Co. Ltd in 1872 and was first described as the No. 3 and Didsbury Hotel in the conveyance of the property to Sarah Hawkes in 1873. It was probably completely rebuilt around that time as, in May 1873, when it advertised itself as being opposite Raikes Hall Gardens, the hotel had public and private entertaining rooms, a billiard room, bowling green, stabling and lock-up Coach House, a cab rank with a drinking trough for horses, strawberry and pleasure gardens and a concert hall. In 1893 the inn was owned by Gartside Ltd of the Brookside Brewery, Ashton-under-Lyne. The bowling green survived until the mid-1960s and the No. 3 is now a 'locally listed' building. The pub was known for a period around 2010 as the Crown (a carvery pub) when it was owned by Mitchells and Butlers but was renamed the No. 3 when it was sold to Spirit Pub Co. in 2014 and is now owned by Greene King and is part of their Flaming Grill chain.

Saddle Inn, No. 286 Whitegate Drive, Marton (c. 1776–present)

The Saddle Inn dates from around 1776, when this area was a rural community and the inn was described as a brewhouse owned by Richard Hall, a saddler of Little Marton. However, it was probably a beerhouse before that date. Richard conveyed the property to Thomas Crookall, maltster of Great Marton in 1814 and around this time the pub was known as the Roundabout House with the front door at what is now the back of the pub (before the kitchen extension). Thomas Crookall died in 1839 and the property was vested with his son George Crookall. It was

The Number 3.

sold in 1844 to William Parkinson of the No. 3 Hotel and ownership of the inn later changed to Matthew Brown of Preston.

The licence was renewed by Catterall and Swarbrick of Poulton in August 1891 and in 1892 William and Eliza Leigh moved from the nearby Oxford Hotel and they and their family were landlords at the Saddle until Jim (James Shepherd Leigh, the beekeeper) retired in 1967.

The separate rooms of the Saddle each had its own name, its own fire and a waiter who could be summoned by bell presses. Roy Edwards, in his booklet *Saddle Up* says that 'wisely' the pub was divided into different drinking areas and working men in dark clothes stayed in the back entrance hall and were expected to leave by 7 p.m. He adds that there was an open bar area, with plain linoleum, where anyone could stand and three different distinct rooms where patrons occupied the same seats, often lunchtime, evenings and weekends. There was the tiny 'House of Lords' room at the front, a 'Men Only' snug until the enactment of the Sex Discrimination Act of 1975, with its red leather bench seating and pictures of the former Marton Council, which used to meet in the room. One regular is said to have stated that 'I used to be able to bring my dog in here but not my wife – now it's the other way round – I much preferred it before.' The 'smoke-room', with its stained-glass panel above the doorway, blue carpeting and oil paintings of sailing ships, was the front lounge. It was converted to a non-smoking room in the 1970s. The long back room with its green-coloured bench seating and pictures of past sporting heroes is still called the 'Commons' and is the domain of the pub's regulars. The pub was acquired by Bass in the 1960s and it was refurbished in 1991. Bass changed the original layout by removing the wall separating the bar area and the 'Lords' room, with the front room now being named the 'Lords'. Pam and Don Ashton started the Saddle Beer Festival in the 1970s and it remains an excellent real ale pub. The Saddle is now owned by the Stonegate Pub Co. and is managed by Alistair Reid.

The Shovels, No. 260 Common Edge Road, Marton Moss (c. 1811–present)

The old Shovels Inn was built in around 1811, adjoining a row of cottages in the rural community called the Fold/Marton Fold, on what was then Moss Edge Lane. It would have catered for the farmers and labourers of the local Marton Moss community, but as Blackpool developed it benefitted from the increased passing trade and from excursion parties getting away from the bustle of Blackpool. The first innkeepers, from 1811 to 1871, were farmer William Singleton

The Saddle. *Inset* Inside the Saddle.

and his family, Thomas Singleton (from 1829) together with his sons, Joseph and John, who were the innkeepers variously through the years. In 1871, Robert Ormond became the innkeeper and in 1873 Thomas Braithwaite was the owner. Thomas took over the licence in 1876 and subsequently his son Ralph was the landlord for over twenty-five years before his death on 21 September 1906. For many years a twelve-bore shooting competition was held every boxing day on the football pitch at the rear of the pub.

The Shovels Inn suffered subsidence and the south gable end was shored up. As part of the development of the area, Common Edge Road was widened and the Fold Row cottages were demolished and work started on the new pub behind the old cottages in June 1955. The new Shovels Inn on Common Edge Road opened on Friday 11 May 1956 and was designed by Mr L. Normington, architect to Mathew Brown (Lion Brewery) Ltd in conjunction with MacKeith Dickinson & Partners of Blackpool. The pub with its lounge bar, public bar and recreational lounge is described in the *Gazette* of 12 May 1956 as being 'the last word in comfort and modernity'. The Shovels is now part of the Flaming Grill chain owned by Greene King. It is a local's pub with several TV screens, football, pool and darts teams, a beer garden and hosts live bands. The landlord is James Drinkwater.

Blackpool Breweries

Catterall & Swarbrick Ltd ('C&S'), Talbot Road Site (1927–1974)

Catterall & Swarbrick was established in 1880 at Queen's Brewery, Queen's Square, Poulton-le-Fylde and in July 1894, William Catterall of Breck Road, Poulton; John Swarbrick of Tower Lodge, Poulton; and Tom Lockwood of the Golden Ball Hotel, Poulton, formed Catterall & Swarbrick Brewery Ltd. The new company then supplied at the Saddle Inn at Great

The Shovels Inn.

Marton and the Star Inn at South Shore and it also purchased the Victoria Hotel in Victoria Street and the Brewers Arms in Cocker Street. The company expanded and purchased many more pubs and hotels in the Blackpool and the Fylde area. It had premises in Kent Road, Revoe (a mineral water works from the early 1900s and later probably a depot) and offices in Princess Street. In 1927, C&S built the 'Queen's Brewery' on the corner of Talbot Road and Abattoir Road near to Devonshire Road and fitted it with the 'latest' glass-lined fermenting tanks. The manager in 1929 was the aptly named Mr Maltman.

C&S XL ales were probably its most well-known bottled beers and in an advert from 1933 it states it is 'available at the Winter Gardens, Tower, Talbot, Railway, Adelphi, Manchester, Clifton, County, Royal, Grosvenor, Star, No. 3, Belle Vue and Bloomfield Hotels and all other C&S Houses'. C&S built the Little Vic in Victoria Street in 1933 and the last pub to be built by the company was the White Hart in Fulwood, Preston in 1954.

In 1961, C&S became part of the United Breweries Group, which later became part of the Charrington organisation before it merged with Bass in 1967 to become Bass Charrington, later Bass plc. Brewing at Talbot Road ceased in 1974 and the buildings were used as a distribution centre. The brewery was demolished in 2000; the site is now residential homes, with roads being named Coopers Way, Catterall Close and Swarbrick Close. There are still traces of the 'C&S' initials to be found in the area on several licensed houses in Blackpool.

Blackpool Brewery Co. Ltd, George Street/Coleridge Road (c. 2000–2013)

The Blackpool Brewing Co. Ltd started brewing beer in part of the old Co-op Dairy building on George Street/Coleridge Road in November 2000, but it is said they had problems with the fermenting vessels and for a while their beer was brewed at Barnsley Brewery Ltd. Among the beers the brewery later produced in Blackpool were Golden Smile and Sweet FA (Fleetwood Ale). The brewery went into liquidation in April 2013.

Blackpool Wyre and Fylde CAMRA by Ian Ward

CAMRA, the Campaign for Real Ale, is an independent, voluntary organisation campaigning for community pubs and consumer rights. It was formed in 1971 and since that time its core aims

C&S Brewery, Talbot Road.

C&S beer bottle labels.

have been to promote real ale and pubs, as well as acting as the consumer's champion in relation to the UK and European beer and drinks industry. The present Blackpool Fylde and Wyre branch was formed in 1980 and is one of the largest CAMRA branches in the country, running successful annual beer festivals as well as having a varied social calendar of trips and get-togethers.

Marton Brewery, behind the Boars Head on Preston Old Road (c. 1890–1910)

After Moses Kay bought the Boars Head in the 1890s, he built and operated a four-storey brewery at the rear of the pub, on the Green Lane site off Preston Road. It was acquired by the Marton Brewery Co. Ltd in July 1905 but brewing ceased in December 1910. The company was acquired by Burtonwood Brewery Co. Ltd in 1913 but was sold again in 1921 and the brewery was demolished in around 1922 to make way for the entrance to Royal Bank Road.

Section 2

'Lost' Pubs (North to South Listing)

Anchorsholme Hotel (later the New Anchor), No. 4 Ancorsholme Lane (1957–c. 1996)

The Anchorsholme Hotel at the corner of Fleetwood Road was built by Magee Marshall of Bolton in 1957 to replace the Moorish Bar of the Cleveleys Hydro, which closed in around 1956. It was opened on 28 June 1957 by its owners Frank and Marjorie Spencer. While this area feels like it is Cleveleys, it is within the Borough of Blackpool and therefore the Anchorsholme Hotel was (as was Cleveleys Hydro) once Blackpool's most northerly pub. It faced south-east and was constructed of handmade rustic facing bricks with lawns to the front. The vestibule entrance had a mural of a Lakeland scene opposite the entrance doorway and there was a large lounge bar, a smoke room and a cocktail bar. The New Anchor pub was a Greenhall's pub when it closed and was demolished in 1996. The site has been occupied since 1996 by a Lidl store.

The New Anchor.

Mariners, No. 8 Norbreck Road (c. 1960–2007)

The building that housed the Mariners Bar was previously Parker's Victoria Private Hotel, situated opposite the Norbreck Hydro Hotel. It was used for many years as accommodation for the staff of the Norbreck Hydro. Before it became the Mariners Bar it was called Maggie Mays. The Mariners was well known for having a good choice of draught beer and lively entertainment which was performed at the front, in the main room to the right of the front door. In the 1970s there was a raised level at the back where Robert Muir recalls the landlord's 'savage' dogs being kept. The building was badly damaged in August 2007 after a blaze broke out in the empty premises and was demolished in 2008.

Uncle Tom's Cabin, Promenade (1858–1907)

From one of three cottages on the cliffs at North Shore, Margaret Parkinson started a refreshment stall on Sundays in the early 1850s selling sweetmeats, gingerbreads, nuts and ginger beer to visitors walking along the clifftops. Margaret's stall was soon replaced with a hut. The name 'Uncle Tom's', given to the expanding premises, is thought to refer to Margaret's brother-in-law, farmer Thomas Parkinson and coincides in time with the publication in 1852 of the popular novel *Uncle Tom's Cabin* by Harriet Beecher Stowe.

In an interview given to the *Blackpool Herald*, published 16 March 1894, Robert Taylor's son John stated that his father had come into possession of Uncle Tom's Cabin when walking along the cliffs (in 1858) he noticed a man pulling down the hut because 'the hut did not pay'. On enquiring, Robert was told that he could buy the hut for £5 and later he and his partner William Parker took over the facilities and extended the premises in 1865–66 by adding a bar parlour, three sitting rooms, bedrooms, a photographic studio and a camera obscura. As a form of advertising and attraction, the three principal figures from Harriet Beecher Stowe's book – Uncle Tom, Little Eva and Topsy – were placed on the roof facing the sea.

Uncle Tom's.

The Taylor/Parker partnership ended in 1875 and in 1882 William Parker gave up proprietorship of the Cabin and became manager of the nearby Duke of Cambridge Hotel (now the Gynn Hotel) at Gynn Square. Continuing erosion to the cliffs made the premises unsafe and after part of the building collapsed into the sea they were closed on Friday 4 October 1907 and the licence transferred to the new hotel across the road. The old buildings were demolished by 12 January 1908 and an article in the *Blackpool Gazette and News* of 14 January 1908 said that it had 'been ruthlessly demolished' with the 'last blow at the weekend' and further that 'builders have no respect for hallowed timbers'. Clearly the *Gazette* writer was in mourning.

Dickson Bar (also known as the Imperial Arms), Dickson Road (c. 1938–c. 1990)

This was a public bar, with a full-size snooker table, on the Imperial Hotel corner of Wilton Parade believed to have been added in around 1938. It is said to have also been known as the Imperial Arms. The large wooden bar facing Dickson Road and green bench seating to the outer walls of the single L-shaped room remain behind the closed doors.

Empress Hotel, No. 59 Exchange Street (c. 1899–2014)

The Empress Hotel was built by a building contractor named Henry Lewtas and opened on 21 December 1899. The licence was transferred from Robert Bentley to Herbert Knowles in January 1930 and in 1933 he advertised 'separate tables and hot and cold water to all bedrooms' and bed and breakfast at *6s 6d* per day. The Thwaites pub retained separate rooms including a large public bar with full-sized snooker table and 'Star Brewery' (Blackburn) windows relating to the home of Daniel Thwaites. Several 'celebrities' and politicians are said to have stayed there over the years including Ted Heath (later the Prime Minister), Sir Robin Day (broadcaster) and Johnny Weissmuller (Olympic champion swimmer and the original Tarzan). It was the only pub in Lancashire to be included in the first twenty-one editions of CAMRA's *Good Beer Guide* from 1972. In later years, it had a large music room with dance floor but closed in June 2014 and was sold in February 2015. It remains unoccupied.

The Empress.

Brewers Arms, Cocker Square (1840s–c. 1898)
The Brewers Arms was part of the old community of Fumbler's Hill and was situated on the corner of Cocker Street and Warbrick Road (later renamed General Street), now the site of a car park. In 1851 the licensee was Richard Laycock and in the 1870s it was owned by George Slater of Burnley. It was bought by C&S around 1893 but was demolished c. 1898.

Derby Arms Hotel, No. 1 Cocker Street (1870–c. 2000)
The Derby Arms Hotel was a pub on the corner of General Street opposite what became known as Cocker Street Baths. In the 1870s the pub was owned by Henry Boddington and was primarily a hotel for families, visitors and 'commercial gentlemen'. The Derby Hotel was a handy place for single people to stay before they got married, as the Register of Marriages for the years 1898–1913 records several people who gave the hotel as their address when getting married at the nearby Christ Church, which was on the corner of Queen Street and Abingdon Street. In the 1970s it was named the Alabama and later it was Liberty's/Alabama Show Bar. It is no longer a pub and is now Liberty's Hotel.

Windmill Hotel (formerly the Mill Inn), West Cliffe Drive, Layton (c. 1836–2010)
Hoo Hill House, near the junction of the old roads from Bispham and Poulton to Layton (Blackpool), is thought to have been constructed in around 1836 by Robert Bonny. He built stables, a bowling green, gardens, obtained a drinks licence and later named it the Mill Inn. Nick Moore informs us that it was known briefly as the Wheel Mill in 1840 and locally as 'Old Betty Wilsons's' in the 1890s. It was bought by C&S in 1924 and by 1930 it was renamed the Windmill Hotel. The Windmill Hotel was demolished in 1979 and a new public house built that looked like a large red-brick bungalow, set back from the road, with a sun lounge facing west onto Westcliffe Drive. The pub, then owned by Mitchells and Butlers, closed in June 2010. The original front doorstep of the old Windmill Hotel can still be seen adjacent the footpath on Westcliffe Drive. A Tesco Express now occupies the modified building.

The Dinmore, Dinmore Avenue, Grange Park (1949–c. 2012)
The first houses on the Grange Park estate were built in 1948. The Dinmore Hotel was a Magee Marshall pub but later changed to Greenhall's. It was later renamed the New Dinmore but

The Windmill.

The Dinmore around 1985.

closed on 13 July 2013 and the pub was sold in July 2014 after its owners, Calco Pubs, went into liquidation. It remains closed today.

Grosvenor Hotel (formerly the Raikes Hotel), Cookson Street (c. 1873–2003)

It is thought that a beerhouse named the Neptune stood on this site in 1872. In 1873/4 George Ormerod, built the Raikes Hall Hotel on the Cookson Street corner with Church Street. The initials 'G.O. 1874' can be seen in the picture on the top corner of the building. Probably so as not to be confused with the Raikes Hall Park Gardens & Aquarium Co., it changed its name in around 1895 to the Grosvenor Hotel when it was owned by C&S. Irish comedian Frank Carson owned the pub in the late 1970s but the pub fell into disrepair and was closed around 2003. It was known in the 1970s for opening on Christmas Day when other pubs were shut. For a while it was the Cow Bar and Hello Dollies. The Grosvenor, along with adjacent properties, was demolished for a 'temporary' car park in 2007.

Grosvenor Hotel.

The Mint (later St Martin's Tavern), Nos 22–28 Clifton Street (1984–2015)

A Liverpool and Martins Bank was built in 1923 and opened in 1924 on the site of a shop and company house. The classical style sandstone frontage is unusual for Blackpool with a 'rusticated' base and six Corinthian columns above. It became Martins Bank in January 1928 and was taken over by Barclays Bank Ltd in December 1969. It closed on 12 November 1982 and became a licensed premise from August 1983. It was the Mint for several years and in the early 1990s it was St Martin's Tavern, owned by Whitbread. In 1994 it was named Never on a Sunday (or Sundays) and later it was Lionel Vinyl; 'Bar: Me' (2000); Green Parrot (2009), owned by Simon Green (better known as Betty Legs Diamond) and Matthew Armstrong; Rouge (c. 2013, a lap dancing bar); and when it closed in 2015 it was Lionel's Bar, a cabaret bar.

Adelphi Hotel, Church Street (c. 1835–1960s)

The hotel was built by Esau Carter in 1835 on the corner of Adelphi Street, adjacent to the Winter Gardens. In 1875 the hotel was owned by George Ormerod. By 1893 the hotel was owned by C&S and Henry Brooks (later Mayor of Blackpool) was the licensee. In December 1923, the building was demolished and a new hotel built by C&S and given a white tiled exterior. The new Adelphi Hotel opened on 23 December 1924 to sandwiches and free beer. The building was partly demolished in the 1960s and replaced by a 'Stylo' shoe shop. Some upper parts of the white tiled fascia are still visible in Church Street and Adelphi Street.

Market Inn/Market Hotel, Lytham Street (now Corporation Street; c. 1850–1923)

In 1855 Mr William Gill was the landlord of the Market Inn, a beerhouse opposite what is now Scruffy Murphys. The Market Hotel was built in 1880 and was designed in an Elizabethan style with oriel windows at each end. It was acquired by Matthew Brown in around 1885. In an advertising book of 1889, the Market Hotel is described as having 'elegantly furnished dining room, smoke room and sitting rooms, and a commodious commercial room, and a fine stock room nine yards by six yards which can be let to travellers.' It closed in 1923.

Oddfellows Arms, No. 4 Euston Street (a street covered by the BHS site; c. 1830–1939)

The Oddfellows Arms, located part way down the cobbled Euston Street, sold Dutton's ales and possibly dated from the 1830s. In January 1856 the landlord was John Atkinson and he sponsored a New Year's Day pigeon shoot sweepstake with 7s 6d which was won by Cuthbert Nickson. It was sometimes known as the Taylor's Arms after its owner and landlord in the 1870s, William Taylor. It closed in 1923 and was used as a warehouse until it was demolished c. 1939 to allow road widening; the site became part of a temporary car park and open market and later BHS.

The Fleece (Later NTK, Ego Bar and now Brannigans), No. 27 Market Street (c. 1840–present)

The three-storey Golden Fleece was built by Richard Braithwaite in the 1840s and became known as the Fleece Inn by the 1860s. By the early 1870s the Fleece was owned by Daniel Thwaites and in 1889 it advertised that it had recently undergone considerable alteration with new furnishing throughout. It was demolished in 1938. A new building, designed by Mr Halstead Best for Thwaites at a cost of £10,000, opened on 27 May 1939. It had a pale blue faience to the lower part of the building with black granite dressings and canopy around the building. On the corner was a 'modern' glass sign depicting 'Jason and the Fleece'. The main entrance to the saloon bar, with its circular bar and striking dome, was at the corner of Market Street and West Street but it

also had an entrance off Market Street to the Smoke Room and another entrance off West Street to the saloon bar. There was also a Jacobean-styled snug bar. The Fleece underwent a complete refit in 1986, when the landlord was Cedric Norton (from Blackburn) and his Blackpool-born wife Anne. It was rebranded by Thwaites *c.* 2000 and is now Brannigans.

The Castle Inn, Market Street (*c.* 1850s–1939)
The Castle Inn was on the Market Street (south side) corner of Euston Street, which ran from Market Street to Corporation Street. The owner of the inn in 1873 was William Carr and in 1889 it was owned by the Threlfall Brewery Co. Ltd. It was demolished in 1939 and the site left as an open car park for fifteen years before becoming part of the BHS site.

The Albion Hotel, Promenade and North Side of Church Street (1828–1925)
The Albion Hotel was built in 1828 by Thomas Nickson on the site of earlier cottages. In the 1830s the *Blackburn Standard* carried an advert for sea-bathing excursions from Halifax to Blackpool, leaving Halifax at 6.45 a.m. and arriving at Nickson's Albion Hotel via Preston. In the early 1870s it was owned by Robert Nickson and by Jane Nickson in 1889. In an 1899 description of some of Blackpool's businesses, the Albion is described as one of Blackpool's oldest hotels and as 'the only first-class commercial house in Blackpool'. It closed on Saturday 18 April 1925. Burton's Buildings housing Montague Burton's large tailors shop was constructed on the site, with Riley's Snooker Hall below for many years. Later it housed a Burger King and has recently been refurbished and is now las iGuanas restaurant.

The Little Vic, Victoria Street (1933–1989), formerly the Victoria Vaults/ Victoria Inn (1870s–1933)
The Little Vic was built for C&S by Sir Lindsay Parkinson and Co. Ltd in 1933 on the site of the old Victoria Vaults (Victoria Inn). The old inn was at the eastern end of the site of the

Left: Central Promenade. *Right*: The Little Vic.

1837 'Victoria Promenade' and had been a public house since the 1870s, when it was owned by William Henry Cocker and later (in 1885) by John E. B. Cocker. In 1888 the inn was let by Matthew Brown but by 1893, John Hall of Cow Gap Lane (now Waterloo Road) was the owner. On 16 December 1933, the *Gazette* reported that a 'transformation has taken place in the last 9 weeks' and 'out of the dust of the demolition of the old Victoria Inn has arisen the gleaming and colourful new façade of what has been renamed The Little Vic.' The Little Vic was designed by John C. Derham, who had created the Winter Gardens' Olympia building and the Spanish Hall suite of rooms. The Little Vic's glorious façade was a blend of Spanish colonial and art deco style in multi-coloured terracotta and it had an antique oak entrance door with a canopy. Andrew Mazzei was engaged to create the Little Vic's interior, again with a Spanish theme and so crafted a 'Spanish mountain tavern'. It is said to have had its bar at the end and booths either side, together with a 'tree' in the centre of the pub surrounded by a wooden ledge to put your drink on. The 'bell' tower at the front of the building was removed in the 1970s. An application to have the building listed failed shortly before it was demolished for shop premises in 1989. The site is now a shop occupied by UIKO, a men's designer clothes shop.

Beach Hotel, Promenade (c. 1840–c. 1893)

The three-storey Beach Hotel was set back a little on the south Promenade corner of Victoria Street adjacent to West Hey, the former home of Sir Benjamin Heywood and now part of the Blackpool Tower site. The licensee in 1851 was Jason Thompson and its address was Hygiene Terrace. In the 1860s it was owned by Blackpool's early historian William Thornber (Reverend) and later by Henry Cocker. By 1889 it was owned by the Central Property Co. Ltd and it was demolished sometime after 1893 to allow the completion of the Tower building.

Tower Lounge, Nos 41–43 Bank Hey Street (1950s–2014)

There was a 'Tower Bar' on the busy Bank Hey Street and Victoria Street corner of the Tower building from the mid-1890s (where KFC is now). From the 1950s, the Tower Lounge, with its

Palatine Hotel, Clarence & Railway Hotel and the New Inn.

Bank Hey Street and Promenade entrances, was a vibrant large bar favoured by holidaymakers. In the summer season it would be packed at lunchtime and in the evening to hear performers or talent shows and was a popular place after wrestling at the Tower in the 1960s. Often described as one of those types of licensed premises where you wiped your feet on the way out due to the spillage of beer on the floor, it closed on 9 November 2014 and is now the new location of Harry Ramsden's fish and chip restaurant.

Welcome Inn, No. 40 Bank Hey Street (1870–c. 1890)
The Welcome Inn was a beerhouse dating from the 1870s and was situated on the corner of Bank Hey Street and Sefton Street (now the site of Boots). It was owned by Cuthbert Fare in 1894 and was purchased by Blackpool Corporation on 4 May 1897.

The White Swan Hotel (later The Swan), Nos 46–48 Bank Hey Street (c. 1880–1980s)
The White Swan Hotel was situated directly behind the Tower and was known locally as the 'Dirty Duck'. The White Swan is recorded in the Register of Licences for 1885 as being at Nos 46–48 Bank Hey Street when the owner was John Leigh. By 1894 it was owned by C&S and became an 'underground' pub sometime in the mid- to late 1970s. It is now the site of the (cellar) 'Underbar' between Boots and HMV on Bank Hey Street.

The Clarence & Railway Hotel, Hounds Hill (c. 1870 to 1930s)
The Clarence dates from c. 1870 and was in an enviable position adjacent to Central Station at Hounds Hill, next to Bannister's Bazaar, later Feldmans Theatre. The hotel also had a 'Music Hall of Varieties' open daily at the back of the building. The site was developed in the late 1930s for a Marks and Spencer's store and is now the site of a Moda Italia clothes shop.

The Palatine Hotel, Promenade, Hounds Hill (1870s–1973)
The Palatine (Family and Commercial) Hotel was a prominent building opposite Central Station. Prior to the hotel being built in the late 1870s, the 'Central Beach' site was occupied by a row of houses named Queens Terrace, built in 1848. In 1899, it advertised that it had been 'newly decorated and re-furnished by Gillow' and it boasted electric light, hot, cold and sea water baths, a new American bar and excellent cuisine. The Palatine was popular with those arriving by train at Central Station in the days when the carriages had compartments without access to toilets. The newly arrived passengers would go straight across the road with their bags and use the facilities in the hotel bar. It was demolished in 1973–74 and the site redeveloped; is currently occupied by the Wild West restaurant and B&M Bargains at promenade level. What was 'The Palace' nightclub above is now the Sands Venue.

The New Inn & Central Hotel, Promenade and Hounds Hill (c. 1840–c. 1973)
The New Inn, adjacent to Central Station was built by James Butcher in the 1840s, adjoining the first cottage along South Beach as it was then called (now the Golden Mile). The name of the inn later changed to Barlow's New Inn and then Duke's New Inn after the names of the new proprietors. Due to congestion in the Hounds Hill/Promenade junction adjacent to the front of Central Station, in late 1896 it was agreed with the New Inn's owner Alderman Robert Butcher Mather that he would demolish the existing building and rebuild the New Inn, 33 feet back by the council of the sum of £6,000. It was rebuilt in 1896 and became the New Inn & Central Hotel. It was demolished in around 1973 as part of the development of the Central Station area and replaced by the Coral Island amusement complex.

The Railway Inn.

The Railway Inn, No. 5 Bonny Street (c. 1920–c. 1967)

The Railway Inn was on the west side of Bonny Street and was a beerhouse licensed to Harry Nickson in 1929. In Barrett's directory of Blackpool of 1952–53, Sidney Bailey is listed as the occupier and in 1967 it was a Wm Younger's pub. The site is now occupied by the Star Attraction amusement arcades and what was previously the Golden Mile Centre.

Our House, Nos 2–4 Oddfellow Street (1870s–c. 1900)

The area behind the 'Golden Mile' length of promenade between Central Station and Chapel Street formed Bonny's Estate. It is thought that the Our House inn (a beerhouse) dates from the 1870s when it was owned by William Monks, Thomas Edelston and Anthony Walmsley and was also a guest house. It had the name 'Our House' carved into the stonework above the doorway on the corner of Cragg Street and Oddfellow Street. It was later owned by the Blackburn Brewery Co. and it is said it was refused a licence in 1903 and closed as a pub shortly thereafter. The photograph shows it as 'Our House Apartments' in 1937. The area was cleared in the early 1960s and is now the site of the police headquarters and court buildings.

The Victoria Hotel, Promenade (1847–c. 1970)

The Victoria Hotel, which was liable to flooding, was on the north side of Brunswick Street and was built by John Bonny in 1847. John Earnshaw was the first landlord, followed by James Cragg. James' brother, William, had bathing vans that were kept in the stables at the rear of the hotel and these were drawn up to the side door so that the lady bathers could be conveyed directly to and from the water. It was owned by John Bickerstaffe in 1889. The Victoria Hotel, seen in the postcard view from approximately 1905, closed around 1970 but part remained for some years as Ripley's Odditorium. It was later demolished and the site is now the Funland amusement arcade.

Concert Inn, No. 64 Bonny Street (c. 1860–c. 1966)

The Concert Inn was on the corner of Bonny Street and Chapel Street where the car park to the Courts is now. In the 1870s the Concert Inn was owned by John Wilkinson. The inn was closed in the mid-1960s and demolished around 1966, when the area on the east side of Bonny Street between Central Station and Chapel Street was cleared.

Our House.

Wylie's South Pier Hotel, Promenade (c. 1850–1904)
A bathhouse (a building equipped for sea bathers with baths) was built by John Bonny in the early 1800s on the north corner of Chapel Street and the Promenade, forward of the other promenade buildings. The South Pier Hotel which replaced the bathhouse dates from before the 1860s and was run by Jonathan Wylie. The owner listed in the 1885–1895 Registers is John Bickerstaffe with John Wylie named as the occupier. It is pictured here in 1900 and it was auctioned in June 1903 and demolished in 1904 with its licence being transferred to the nearby King Edward VII Hotel.

Farmers Arms, No. 7 Chapel Street (c. 1880–c. 1900)
In 1866 a beerhouse named the Farmers Arms occupied the Chapel Street/Dale Street corner site and in 1895 Delia Buckley is listed as the occupier (licensee). The building is now Arkwrights convenience store and there is no sign of it ever having being a pub.

The Wellington and Pier Hotel, Promenade and Chapel Street (1851–1990s)
The hotel was built in 1851 by Robert Bickerstaffe, opposite what was then South Pier (now Central Pier), as a family hotel with forty bedrooms. In the 1870s the hotel was owned and run by Robert's son John who, in 1895, was granted a seasonal licence for singing, music and dancing from 10 a.m. to 10.30 p.m. It was rebuilt *c.* 1953 in a vague art deco style. It was later the Tavern in the Town and in the 2000s was, in part, a McDonald's and is now occupied by holiday souvenir shops/kiosks.

Prince of Wales (later the Gauntlet and the Jaggy Thistle), Nos 10–12 York Street (c. 1860–c. 2010)
The Prince of Wales Inn dates from before the 1870s and was demolished in the late 1960s. A new building housing the Gauntlet was built in the 1970s, which became the Jaggy Thistle in the late 1990s. The Jaggy Thistle was a Scottish flavour bar on the corner of York Street and

Above: Concert Inn.

Below: The Victoria Hotel.

Cragg Street. It billed itself as 'The World Famous Jaggy Thistle'. It had a bar and concert room, karaoke on every night, with prizes, a pool table and two big screens. The *Rough Pub Guide* co-author, Paul Moody, joked that he felt 'lucky to be alive' when leaving the Thistle. It closed *c.* 2010 and was sold in June 2011. It is now a car park.

Atlantic Hotel, Foxhall Road (c. 1880–1922)

In 1885 Robert Bickerstaffe owned the Atlantic Hotel at the north corner of Foxhall Road and Yorkshire Street and Josias Dagger was the landlord. By 1894 it was owned by C&S and was licensed for singing and music in the season. The Atlantic Hotel was closed in March 1922.

Bay Horse Inn, Lytham Road (c. 1870–c. 1880s)

Little is known about this commonly named pub which was situated somewhere on Lytham Road in the 1870s to 1880s. It is included in the 1873 Register when it was owned by Ellen McLevy. The pub was owned from around 1874 by Matthew Brown but not included in the 1887 Register. It is possible it was situated on the corner of Lytham Road and St Chads Road.

The Exchange Wine Bar (later the Noggin and Legends and the Brigadier Gerard), Nos 98–100 Bolton Street (1939–2010)

The old Exchange Wine Bar was said to be one of Blackpool's oldest licensed premises, although it is not included in the 1873–95 register of licensed premises. It was rebuilt and extended into adjoining shops by John Smiths, brewers of Tadcaster to the design of Halstead Best and opened in the spring of 1939, comprising a lounge and separate public bar. It became the Noggin in the mid-1970s and in 1997 it was named Legends and owned by Inntrepreneur Pub Company Limited. It was later renamed the Exchange and by 2010 it was the Brigadier Gerard. It remained as a pub until about April 2010 after which time it was converted into two self-contained flats and all the character of the 1939 frontage has been lost.

Wylie's South Pier Hotel.

Bird-in-Hand, Bolton Street (1860s–c. 1900)

The Bird-in-Hand is included in an 1866 directory and is recorded in the 1887 register as being at No. 28 Bolton Street, when the Sun Inn was then at No. 14 Bolton Street (it is now at No. 88 Bolton Street). By 1885, the Bird-in-Hand was owned by C&S. Its exact location or when it closed is not currently known.

Bowling Green Inn, Waterloo Road and Bath Street (1860s–late 1930s)

The Bowling Green Inn, as its name would suggest, had a bowling green and occupied the block between Bath Street and Bond Street and Waterloo Road. A beerhouse in Bath Street is recorded in an 1886 Blackpool directory when the licensee was Francis Ball. In April 1905, John Taylor (a confectioner) occupied the Bowling Green Inn. After John left in 1906, Daniel Haye claimed that the bowling green required relaying in places and the house needed decorating. Both men claimed and counter-claimed sums against each other, with John obtaining judgment for £38 5s 9d, being the balance of his 'ingoing' and Daniel being awarded £3 15s 3d on his counterclaim. The pub was run by John B. Eastham in 1938 but shortly after the land was occupied by the South Shore premises of Woolworth's until it closed. It is now occupied by Hartes Home Store.

Waterloo Tavern, Cow Gap Lane (Now Waterloo Road; c. 1870–c. 1890)

The Waterloo Tavern was on Cow Gap Lane (renamed Waterloo Road c. 1915) and was close to South Shore Football Club's ground on the north side of Cow Gap Lane just to the east of where Blackpool South railway station is today. In the 1870s William Shaw of Marton was the owner and in 1889 it was owned by the Manchester, Sheffield and Lincoln Railway Co. It is thought that the tavern was demolished sometime in the early 1890s to allow the construction of the railway sidings to the north of Waterloo Road.

Lord Nelson Inn, Preston Old Road (c. 1840–c. 1890)

The Lord Nelson in Great Marton Village was an alehouse which opened in c. 1840. It was situated where the dwelling at No. 15 Preston Old Road now stands, near to the Boars Head pub. It was extended in 1858 and new 'tea gardens' were opened. In 1873 Elizabeth Johnson was the owner of the Lord Nelson and James Barrow was licenced to sell beer and cider. The

The Jaggy Thistle.

property later became the Boar's Head Chippy and then the Far East Chinese Takeaway, which closed in 2011.

The Oxford (formerly the Mill Inn), Oxford Square (1840s–2009)

From around 1775, this was the site of a corn windmill, dwelling house, drying kiln, granaries, stables and other outbuildings together with gardens, at Marton Green. A hostelry opened in the early 1840s and was then known as the Mill Inn near to the windmill. John Bamber was the owner and licensee of the Mill Inn in the early 1870s and in 1876 Messrs Flitcroft and Grime became the owners and soon after the dwelling house and inn were rebuilt and renamed the Oxford. In 1889 it was described as the Mill Inn and Oxford Hotel and advertised itself as 'a pleasant drive from Blackpool or South Shore'. In 1895 it was owned by the Bedford Brewery and Malting Co. Ltd of Bedford Leigh near Manchester and later it became a C&S pub. In the 1960s, laburnums still grew against its walls of local brick. In 2007 the Oxford was renamed Bickerstaffes but closed in October 2009 and was demolished in February 2015. The site has been occupied by a new Aldi supermarket since November 2015.

Cherry Tree Gardens Hotel, Cherry Tree Road, Marton (c. 1851–1971)

The Cherry Tree Gardens Hotel developed in around 1851 from the Cherry Tree Farm and Nursery, built by Joseph Todd. In an advertisement in the *Fleetwood Chronicle* of 1854 it says that admission to the gardens is by ticket but that the amount paid is repaid in flowers or fruit. It was run in the early 1880s by the Fisher family. Its gardens, licensed bars with singing and dancing, outdoor beer gardens and bowling greens were a popular 'excursion' by horse wagonette from the hustle and bustle of Blackpool. In Whit week of 1897 over 8,500 people passed the turnstiles. It was sold in the late 1890s for £8,500 to a Mr Richard Caldwell. In the mid-1960s it was known as Sunset lounge before becoming Your Father's Mustache (an American franchise) in 1968–71 with banjo/oompah jazz band entertainment. It sold beer in 4-pint jugs, its tables were nailed down and they played silent Laurel and Hardy movies during the breaks between bands. YFM closed on 7 November 1971 and was purchased by Blackpool Corporation from Dutton's Brewery Ltd on 29 March 1972. It was used as Cherry Tree House Old Folks Home, which closed in 2007 and was demolished in July 2008. Tulluch Court 'extra care' apartments for older people, were completed in October 2010 and the housing scheme is named after Bert Tulloch (23 February 1889–15 February 1953), who played football for Blackpool FC between 1914 and 1924 and was the licensee of the Cherry Tree Gardens Hotel from 1934 until his death in 1953.

The Royal (now a Tesco Express), Marton Drive (1936–c. 2009)

The Royal Hotel was built for Messrs Westwell and Hague and opened on 23 December 1936. Its licence was transferred from the old Royal Hotel on the Promenade. It was built with rustic bricks and stone dressings and a dark rosemary brindled tiled roof. The vaults were accessed from Harcourt Road. The saloon had a smoking room attached and there was a large billiards room to the rear. All the bars were served from a central island bar. It was a Whitbread pub in the 1980s but closed in around 2009 and is now a Tesco Express.

The Grand Hotel, Station Road (c. 1890s–2008)

The Grand Hotel was built in the 1890s and had sixty bedrooms. Magee Marshall acquired the lease for several years and the licenced premises were taken over by C&S in the early 1950s, when it was converted into a public house. In October 1985, Bass Lancashire carried out a £150,000 refurbishment, retaining the large original mahogany bar. It had a games room, family

Above: The Oxford Hotel, 1963.

Below: Cherry Tree Gardens.

room and a large main lounge. In recent years its upper floors were converted into self-catering apartments. It closed in 2008 and the property was for sale when it burnt down on 28 July 2009 and was subsequently demolished. The site has not yet been redeveloped.

Flannagans (formerly the Beach Hotel, Beach Tavern and Tommy Duck's), Promenade, South Side Corner of Station Road (1925–2016)

A pair of houses occupied this site in the 1880s before South (Victoria) Pier was constructed in 1892–93. The Beach Hotel was opened in 1900 as a café and restaurant and, in 1925, the owner (Alderman J. R. Quayle JP) had the licence for the Albion Hotel (Promenade and Church Street) transferred when it closed in April 1925. The hotel was bought by J. W. Lees & Co. in 1930 and was sold to Dutton's Blackburn Brewery Ltd in 1937. It was later owned by Whitbread and became the Beach Tavern. It was sold to David Perkin's Rossbranch Pub Co. in 2008 after the owners at the time, Laurel Pub Co., went into administration. It became Tommy Duck's for a while and was renamed Flannagans in 2015. The pub was converted to retail premises in 2016 and is now largely occupied by a Subway sandwich shop.

Star Inn (formerly the Seven Stars; 1840s–1931)

The Seven Stars beerhouse was built in the 1840s just above the high water line of the beach, adjacent to the sand hills at South Shore, to the south of what would become the Pleasure Beach. It was protected from the sea only by a sloping pitched stone apron to the front and north side of the building. In the 1850s the landlord of the Seven Stars (a Robinsons pub) was Josiah Hargreaves. By 1885, when John Kirkby was the occupier, it was known as the Star Inn. As the Pleasure Beach and area developed in the early 1900s, a large platform was added to the south frontage. It was purchased by C&S in around 1887. The New South Promenade was completed by the council between 1923 and 1926 and a new Star Hotel was erected in the 1931, fronting the new promenade, and the old Star Inn was demolished.

The Star Inn, seen here in around 1920.

Section 3

The Town Centre

The Town Centre

1. Kings Bar
2. Peek-a-Booze
3. Casey's Bar
4. Duke of York
5. Man Bar
6. R Bar
7. Kaos
8. The Flying Handbag
9. Buckinghams Bar
10. Roxy's
11. Bar 19
12. The Litten Tree
13. Walkabout
14. Nellie Deans
15. Galleon Bar
16. Ned Kelly's
17. The Hop
18. The Blue Room
19. Frenchman's Cove
20. The Townsman
21. Gillespies
22. Churchills
23. Cedar Tavern
24. The Washington
25. Rose and Crown
26. Scruffy Murphys
27. Yates
28. Shenanigans
29. The Layton Rakes
30. The Mitre
31. Brannigans
32. Revolution
33. The Albert and the Lion

1. Kings Bar, formerly the Mount Pleasant; 1870s–present, No. 103 High Street

The Mount Pleasant on the corner of High Street and Cocker Street was built in around 1850 and was owned by Matthew Brown in the 1870s. It was a small, cosy pub frequented mainly by locals and was extended into No. 105 High Street in about 1992. It closed in 2014. Before it closed it advertised itself as giving 'a warm welcome' with pool, darts, entertainment and comfortable lounge areas. It also fenced in the front garden area for outdoor use to enjoy the west-facing afternoon and evening sun. The Kings Bar was officially opened during Pride Week on 13 June 2015 by owners Sue Northover and Franki Du Mongh as 'the UK's first Drag King Bar' and advertises itself as 'owned by women for women'.

2. Peek-a-Booze, Nos 72–74 Dickson Road (c. 2012–present)

Peek-a-Booze is a cabaret bar and hotel with live entertainment, drag shows and karaoke. It was formerly the three-storey Stratford Hotel.

3. Casey's Bar, Nos 68–70 Dickson Road (c. 2015–present)

Casey's Bar is an Irish bar that was previously Firgrove House (in the 1940s) and later the Firgrove Hotel until around 2011. A sign above the second floor states that the property was built in 1876 and was then part of North Parade.

4. Duke of York, No. 60 Dickson Road (1880s–present)

In August 1889, Henry Hall owned the original Duke of York Hotel at No. 28 Banks Street and John Irish was the landlord. The 'new' three-storey Duke of York Hotel was designed by Halstead Best for the Thwaites Co. and the property was rebuilt at a cost of £8,000. It reopened on 27 May 1939. From its corner entrance access was gained to a large saloon bar and the

Left: Kings Bar. *Right*: Peek-a-Booze.

The Duke of York.

smoke room was accessed from the Banks Street entrance. There was also a small outdoor department with an entrance on Banks Street. The building is clad in cream faience to the upper two floors with a black granite base and a carved panel of the Duke of York high on the Bank's Street elevation. The Thwaites pub has largely retained its external appearance and has a fenced beer garden to the front and side of the pub; inside it has a large U-shaped main lounge, a food bar, pool table, televisions and features karaoke at weekends.

5. Man Bar (formerly Kitty's Showbar, Taboo), No. 23 Dickson Road (2015–present)

A Williams Deacon Bank RBS occupied this site from at least 1925 until the 1980s and later we understand it was a solicitor's office, with the Gwalia Hotel above. It had several uses thereafter, including a clothes shop named Clubwear 2000 UK; the Cruz Bar; Kitty's Showbar/Taboo bar; then the Queen Vic. It became the Man Bar in 2015 and is a free house with two rooms, a pool table at the rear and a live DJ.

6. R Bar, No. 1 Lord Street (2012–present)

The ground floor of Christine's Hotel became the R Bar *c.* 2012 and has live music and entertainment.

7. Kaos, Nos 38–42 Queen Street (2006–present)

In the 1950s, Coar's fish and chip shop occupied this part of the Station Buildings, then adjacent to North Station, and the building was later used as a restaurant. It became Club Rendez-Vous and Kaos – 'it's a gay thing' – around 2006. It has two rooms, with a dance floor and stage in the main room, served by a central bar, and has a small fenced area outside.

8. The Flying Handbag, No. 44 Queen Street (2005–present)

The original Flying Handbag was on Talbot Road (the old Kings Arms). It relocated to new premises in Queen Street and opened in late 2005. It is at the centre of Blackpool's extensive gay nightclub scene. There is a stage near the door onto Queen Street and the bar has cabaret nightly

hosted by a drag DJ. It has a large horseshoe bar area which opens out onto a terrace at ground floor, a pool table and a rooftop terrace at first floor.

9. Buckinghams Bar, No. 35 Queen Street (2009–present)
The building was occupied by Solicitors H. P. May and Hamer in the 1920s and Mellelieu & Son, boot deliverers, in the 1930s. It was later a restaurant thought to be named Spice of India. Buckinghams opened in around 2009 and is a welcoming and friendly single room bar that has karaoke on Tuesdays and Sundays and live music on Thursdays and Saturdays.

10. Roxy's, No. 23 Queen Street (2003–present)
In the 1930s and 1940s this property was the Hazel Hotel and in the 1970s the building housed Harts (silversmiths) with offices above. Later it changed to a caterware shop and in the mid-1990s was vacant for a period before In the Pink Leisure Group acquired the property, remodelling and extending it into what we see today with its large windows, cantilevered balcony and decorative columns. It became Fayes café bar in around 2000 and changed its name to Roxy's in 2003. It opens in the evening and has four separate bars, themed on the musical 'Chicago' with female impersonators, vocalists and speciality entertainment acts.

11. Bar 19, No. 19 Queen Street (2006–present)
Bar 19 was once Miss Florence Spring's ladies outfitters shop at No. 19 Queen Street and was later Sedgwick's china shop before it became a bar in around 2006. It is now a single-room free house bar that is open late.

Left: The Flying Handbag. *Right*: Bar 19.

The Litten Tree.

Walkabout.

12. The Litten Tree, Nos 8–14 Queen Street (2003–present)
For many years the building that is now the Litten Tree was the Blackpool Employment Exchange. A canopy to the front of what were then retail units was erected in 2000 and in May 2003 the Litten Tree was opened. It has a large open area inside with a DJ at the weekends and is popular with locals and visitors. The canopied area to the front now has seating and the pub is owned by Stonegate.

13. Walkabout, Nos 1–9 Queen Street (2002–present)
This row of properties in Queen Street dates from Victorian times and was (partly) Funny Girls from 4 July 1994 before they moved to the Dickson Road 'Odeon' site in March 2002. It became

Galleon Bar

Walkabout (with the 'b' written backwards) in around 2002 and is an Australian-style sports pub; many Australian staff who live above the premises. It suffered an extensive fire on 19 June 2013 and was completely refurbished. It has a large single room with raised areas and a very large screen behind the bar for watching sport. It also has an upstairs room, open at weekends, for entertainment.

14. Nellie Deans, Nos 150–152 Promenade (2003–present)

Nellie Deans was opened in around 2003 by Thwaites in part of what was originally Albert Terrace, completed in 1848, opposite what is now the Grand Metropole.

15. Galleon Bar, Nos 68–70 Abingdon Street (2010–present)

The original (basement) Galleon Bar was on Adelaide Street for some fifty years and offered live jazz and sold Vaux beer. It was a favourite haunt of musicians from the theatres. It closed in 2005 and was demolished in around 2010 to make way for the extension to the Hounds Hill Shopping Centre. In December 2010, Blackpool-born entertainer Stephen Pierre relaunched the Galleon Bar on Abingdon Street in what was Mac Fisheries in the 1970s, a tile shop, Lucy's Two Bar (c. 2008), Time Out and later Jack's Sports Bar. It is now a live music venue with karaoke and 'open mic' nights. Stephen also regularly sings his repertoire.

16. Ned Kelly's (formerly Schofields, Copacabana), Nos 19–23 Clifton Street

Formerly the offices of the Halifax Building Society, it was later changed to licensed premises trading as Schofields (c. 2001) and later Copacabana. Ned Kelly's Irish bar, with live entertainment, karaoke and a carvery now occupy this site from the summer of 2016.

17. The Hop (formerly the Veevers Arms), Nos 2–4 King Street (1870s–present)

The Veevers Arms Hotel was named after Richard Veevers, a Land Agent of Preston. It was granted a new spirit licence on 5 September 1872 and a music licence in 1895 and was owned by John Noblett until his death in 1889. It was bought by Threlfall's Brewery in 1900, who were

Above: The Hop

Below: The Blue Room

taken over by Whitbread in 1967 and it is now known as The Hop, owned by Greene King. It has a pool table and two dartboards and hosts quiz and poker nights, karaoke and live music.

18. The Blue Room (the Stanley Arms Hotel), No. 139 Church Street (1880s–present)
The Stanley Arms was named after Frederick Stanley, 16th Earl of Derby, MP for Blackpool between 1885–86. The original Stanley Arms stood on Stanley Terrace in the 1870s, across the road from the present pub and the Stanley Arms Hotel was built in 1880 by Whittaker Bond on the Church Street corner of South King Street (then Lower King Street). Built in golden sandstone it has carved timber fretting to its gables. Blackpool Football Club was formed in the Stanley Arms Hotel on 26 July 1887. The Stanley Arms Hotel has had several names over the years, including the Hogs Head Ale House/Beer Engine (1990s) but is most commonly known as the Blue Room, due to its use by police officers from the nearby police headquarters in Lower/South King Street, which opened in 1893. The Blue Room has closed and reopened a number of times in recent years and as of July 2016, it is closed.

19. Frenchman's Cove, No. 15 South King Street (2000–present)
Frenchman's Cove, with its pirate statue overlooking the street from the upstairs balcony, was opened in around 2000 in Duckworth's tobacco warehouse on South King Street. It has a pool table, live sports, beer garden at the rear, bands and a disco and karaoke at weekends. Nikki, the manager, has witnessed the ghostly activity of a little girl called Laura.

20. The Townsman, No. 96 Topping Street (2010–present)
This site has had several occupants, including comedian Jack Diamond's cabaret venture, Aphrodite's lap dance club and Connolly's Irish bar. It reopened in November 2010 as The Townsman.

21. Gillespies, (formerly the Shakespeare Hotel and earlier Carter's Arms), Nos 87–89 Topping Street (c. 1860–present)
In the 1885 Register of Licenses, the pub on this site (then No. 33 Topping Street) was named Carter's Arms and was owned by Thomas Gornall. By 1894 Threlfall Brewery Co. had bought the pub and changed its name to the Shakespeare Hotel. The pub was modernised and refaced in the 1930s with cream faience. Georgie Mee, who played for Blackpool FC 216 times 1920–26, was the licensee after he retired and the pub became known for a while as Georgie Mee's in the 1960s. It later changed its name to Gillespie's, a large open-plan pub with darts, dominoes, pool table and large screen for live sport.

22. Churchill's (formerly the Criterion Hotel and earlier the Huddersfield Arms), Nos 83–85 Topping Street (1860s–present)
The Huddersfield Arms stood on this site from the 1860s to 1890s (then No. 31 Topping Street) and in 1895 the owner was James E. Schofield. It was rebuilt by Joshua Tetley & Son Ltd Leeds and still has the large terrazzo lettering outside the main door onto Topping Street: 'TETLEYS ... CRITERION ... HOTEL'. The pub changed its name to Churchill's in 2005 and Margaret, the landlady, now hosts bingo and quiz sessions three times a week with drag acts on high days and karaoke on Fridays and Saturdays.

23. Cedar Tavern, No. 15 Cedar Square (c. 1950s–present)
Properties in Cedar Square date from around 1860 and the building we see today was designed by J. C. Derham as offices in a striking classical design, built around 1931. The building initially

Above: Churchill's.

Below: Cedar Tavern.

Scruffy Murphys.

housed accountants/solicitors and the Blackpool offices of the Liverpool & London & Globe Insurance Co., Ltd before it became the Cedar Tavern. It was called White's Bar for a while when it was owned by Tom White, who played for Blackpool FC between 1968 and 69. The Cedar Tavern closed between 2007 and 2009 and is a now a locally listed building. The pub is said to be subject to paranormal activity and featured in a 2013 reality TV programme named *Paranormal Intent* investigating alleged sightings of a young child playing hide and seek in the building. The pub is now run by Warwick and hosts live music, a DJ, open-mic nights and karaoke.

24. The Washington, Topping Street (1875–present)
Built in 1875 on the corner of Deansgate, in 1887 it advertised itself as having the finest concert room in Blackpool that could seat 130 people and that it was open all day during the summer season with free admission. It is now a large open-plan pub with pool table and darts, a projector for sport and serves pub food. It is owned by Greene King and is a 'Meet & Greet' bar and grill with live bands at weekends in the summer season.

25. Rose & Crown, Nos 22–24 Corporation Street (1840s–present)
Formerly named the Crown Hotel at what was then No. 14 Lytham Street on the corner of Birley Street, the hotel was owned by the Oldham Brewery Co. Ltd in 1893 and was granted a seasonal music licence in 1895. The Rose & Crown pub was rebuilt on Corporation Street in 1963 and it now markets itself as a family–friendly food pub with café-style seating outside.

26. Scruffy Murphys (formerly the Grapes), No. 32 Corporation Street (c. 1840–present)
This pub was known as the Grapes at No. 22 Lytham Street before the street's name was changed to Corporation Street in 1925. In 1889 it was owned by John Gartside & Co. of the Brookside Brewery, Ashton-under-Lyne. In the 1920s, John James Brook was the licensee and the pub was

Yates.

owned by Burtonwood Brewery Co. Ltd. Burtonwood rebuilt the pub in 1931 to a design of J. B. Singleton with a small lounge, snug and smoke room with stained-glass windows. For a long time it was a Tetley pub. It is now an Irish-themed pub with Irish singers and karaoke. It has retained its stained-glass windows, separate rooms with main bar, pool room at the rear, front room and quiet room.

27. Yates (formerly Cahoots), No. 100 Promenade and Nos 13–15 Market Street (late 1990s–present)

The upper pediment of this classic faience-clad 1920s' building adjacent to the Clifton Hotel states it was built as Feldman's Arcade and ran from Market Street through to the Promenade. At first, it housed a live music emporium. In later years it was named the Clifton Arcade and the walk-through arcade housed high-class shops such as the Powder Bowl and Diana Warren (1960s to 1980s). Later still, it became a market-type arcade and Cahoots at the end of the 1990s. It is now marketed as Yates by the Stonegate Pub Co. and is a large room which runs from Market Street to the Promenade with a DJ at weekends and an upstairs area for parties and cocktail-mixing masterclasses.

28. Shenanigans, Nos 94–98 Promenade (2013–present)

This building housed Lyons Piano Shop in the 1920s and was also Collinsons Café. It became a cowboy-themed bar in the mid-1990s (replete with swinging doors) named the Saloon Bar. It was later the Uno Bar and was Chubby's R&B Bar in 2010. It became Shenanigans in 2013 and is a fun and sports bar with live music and karaoke.

Layton Rakes.

29. The Layton Rakes, Nos 17–25 Market Street (2011–present)
Plans to demolish the retail properties on Market Street and West Street and build a new two-storey public house were in progress as early as 1999, when the buildings on Market Street were occupied by Allens Chicken and Exec-Lighting and on West Street by the Scullery Café and West End Gifts. The Layton Rakes pub, a Wetherspoon's, opened on 22 November 2011. The pub has two floors and a roof terrace area. In the downstairs bar is an illuminated sculpture of Tower Circus entertainer Charlie Cairoli, a large mural depicting local landmark buildings, fixed seating in the style of a waltzer, a carousel horse and crazy 'Fun House' type mirrors.

30. The Mitre (formerly Ye Old Glue Pot), No. 3 West Street (1880s–present)
The Mitre is said to be Blackpool's smallest pub and was originally a grocer's house and shop in what was known as Dobson's Row, dating from the eighteenth century. Premises owned by John H. Walker in West Street, thought to be these, were licensed to sell beer and wine in 1880s and it said that the 'Ye Old Glue Pot', as it was known, was first fully licensed in 1898 before it became known as the Mitre Inn in 1902. In 1929 it sold Nuttall's ales and stouts and the proprietor was Russell Howarth. During renovation works in 2012, builders found a petrified cat between the roof rafters. After completion of the work the builders replaced the cat in its final resting place between the rafters.

31. Brannigans (formerly The Fleece, NTK, and the Ego Bar), No. 27 Market Street (2016)
After the closure of the Fleece in around 2000, (*see* Section 3, Lost Pubs) this building was rebranded by Thwaites and has had several occupants. It has been named NTK (Need to

Above: Layton Rakes' interior.

Below: The Mitre.

Know) from around 2000, Ego from around 2013 and is now Brannigans. NTK had signs that advertised itself as having been voted the National Pub of the Year (2008). Ego was a bar/nightclub and the three-storey building was painted black. Brannigans reopened in March 2016, just a few doors up from its previous location.

32. Revolution, No. 35 Market Street/Promenade

This site was previously the Gaiety Bar and later Brannigans from 1989 until 2011, when the parent company, Cougar Leisure Ltd, went into administration. The inside is said to have featured 'a wealth of brass and wood, Tiffany-style glass and print-lined walls'. Paul Schofield was the DJ from 1989 to 1999. It opened as the Revolution bar (with the letter 'e' written backwards) in July 2011.

33. The Albert and The Lion, Promenade (2010–present)

After Woolworth's closed in 1984, this site became Price Busters, a large indoor market that opened in April 1985 but closed in 2007. The Albert and the Lion opened on 2 July 2010 and is named after the 1932 poem by Marriott Edgar, made famous by Stanley Holloway's comic monologue titled 'The Lion and Albert'. The Albert and the Lion is owned by JD Wetherspoon. A feature of the large open pub is a wooden sculpture of a lion's head. In its mouth, Albert can be seen disappearing.

Other Bars

There are other bars in and around the town centre that are not detailed in the book and these include the Soul Suite on Queens Promenade; Venom on Queen Street; Freddie's Bar on Dickson Road; the Theatre Bar (Bar Red) at the Winter Gardens; Venom (Bar 137) on Church Street; Don Pepe Cocktail Bar on King Street; and the Gaiety Karaoke Bar on the Promenade.

The Albert & The Lion

Above: The Washington (*see* page 45).

Below: Brannigans (*see* page 47).

Section 4

Talbot Road – from The Layton

Talbot Road

1. The Layton
2. The Queens
3. New Road Inn
4. Ramsden Arms Hotel
5. Wheatsheaf
6. Kings Arms
7. Talbot Hotel
8. Ma Kellys
9. The Imperial
10. Pepes Bar
11. The Victoria (Whittle Springs)
12. Molloy's
13. Yates's Wine Lodge
14. Nyx Bar
15. Clifton Hotel
16. Counting House
17. Merrie England Bar

1. The Layton (formerly Layton Institute), No. 30 Westcliffe Drive, Layton (1925–present)

The first Layton Institute was opened on 8 November 1912 in a barn at Little Layton before it moved to a bungalow on the east side of Westcliffe Drive near Lynwood Avenue. The foundation stone for Layton Institute (a working men's club) was laid in June 1925. Layton Institute was renowned for its entertainment with acts such as Matt Munro, Joe Longthorne and the Nolans performing there over the years. The club was made famous in 1995 when Paul O'Grady's creation 'Lily Savage' filmed his *Live from the Lilydrome* TV show there. The Institute closed on Sunday 12 August 2012 but reopened the next month as a pub and is now The Layton. The bowling green is no longer used for bowling but the upstairs function room remains. The snooker room has two full-sized and four smaller snooker tables and a pool table and has green leather covered booths at the side. On the other side of the central bar is the lounge and the 'Vets Bunker' at a lower level.

2. The Queens, No. 271 Talbot Road (c. 1894–present)

The Queens was built on New Road, Layton in around 1864 by W. H. Gaulter and was owned by Thomas Fisher in 1873. In 1877 the landlord was fined £1 plus costs for having his house open out of the prescribed hours. The hotel was altered in 1902 and is now owned by Amber Taverns; it has a large lounge, separate 'vaults' with a pool table and dartboard. The pub hosts live bands on Saturday night, bingo on Wednesday and it has pool, darts and dominoes teams. The front of the pub now has a raised and enclosed south-facing seating area, popular on sunny days. Like many Blackpool pubs, it had a bowling green to the rear of the pub but this was built over with houses and Peel Avenue in the 1930s.

3. New Road Inn, No. 244 Talbot Road (1870s–present)

The original New Road Inn was built in the 1870s as a three-storey building on New Road, on the corner of Elizabeth Street. In 1885 the pub was owned by William Flitcroft and from

The Layton.

Above: The Queens.

Below: New Road Inn.

around 1893 it was owned by C&S, who rebuilt it in the 1940s. It was later owned by Jennings and is now a free house with real ales. The separate rooms to the pub were removed, in part, in the 1970s and the pub has a lounge at the front, a pool room and an 'oval' room at the rear. It has teams in the Fylde pool league and Blackpool darts league. The pub also hosts karaoke on Friday and Saturday nights and has an open-mic night on Sundays.

4. Ramsden Arms Hotel (formerly the Golden Lion), No. 204 Talbot Road (c. 1865–present)

A short history of the Ramsden Arms is framed in the pub and states that the land on Talbot Road, close to Talbot Road Station, was purchased by John Dewhurst in 1865 and the Golden Lion was built. John Dewhurst sold the pub in 1888 to the North Cheshire Brewing Co. and it was later purchased by John Taylor Ramsden in 1890. In 1894, its address was No. 6 New Road. The Golden Lion was demolished for the widening of Talbot Road and the (new) Ramsden Arms Hotel ('the Rammy') was built in 1939 by Halifax brewers Thomas Ramsden. Thomas Ramsden & Son of Halifax were taken over by Allied Breweries in 1964.

The Ramsden has retained many of its original features and character, including wood panelling, three fireplaces and marquetry panels depicting hunting scenes. Since 1998, John Davies has been the landlord; before John it was Albert Caffrey from 1986 to 1998, and before Albert the landlord was Jackie May. It has a snooker table in the old vaults room, as well as a pool table, and has teams in the local leagues. It was CAMRA Pub of the Year in 1988–89.

Ramsden Arms Hotel. *Inset*: John Davies, landlord of the Ramsden.

5. Wheatsheaf, Nos 192–194 Talbot Road (c. 1880–c. 2004)

The address of the Wheat Sheaf Inn in 1889 was Nos 1 and 2 New Road. It was later owned by Matthew Brown and was unique in having Theakston Bitter, XB and Old Peculiar on tap. The Wheatsheaf was rebuilt in the 1930s on the east corner of Lark Hill Street and was an excellent real ale pub. It is described in CAMRA's 1994 booklet *Piers & Pints* as a 'lively, basic and down-to-earth drinking house but with an added touch of sophistication (chandeliers in the lounge) as a result of refurbishment in 1990.' The last landlord of the Wheatsheaf was the well-loved Barrie Eastwood. The Lost Pubs Project described it as 'Just a short walk from Blackpool North Station, the Wheatsheaf was a quite amazing pub. Excellent real ale and cheap, but satisfying, food didn't tell the full story of this unique pub. It was like stepping back in time.' The interior walls were covered with music memorabilia from the 1960s and the pub contained two full-sized patriotic statue figures of a man and woman (Worzell Gummage and Aunt Sally) who would wave Union Jack flags when fed with the appropriate coins. The pub closed in July 2004 and was purchased by the council. It later fell victim to fire and was demolished in around 2007 to make way for the Talbot Gateway development. It was generally at the location of the entrance to the new Sainsbury's car park.

6. The Kings Arms (was also the Flying Handbag), No. 172 Talbot Road (1860s–2007)

The Kings Arms was built around 1860 on the corner of New Road and what became Swainson Street. In 1866 Thomas Taylor was the landlord and in 1870 Thomas Poole Snr moved from the Red Lion in Bispham to the Kings Arms. The Kings Arms was the only pub in Blackpool owned by Higsons Brewery of Liverpool and was the venue for the first Fylde CAMRA branch meeting, held in 1980. Higsons Brewery was taken over by Boddingtons in 1985 and the Kings Arms was renovated in 1987, dispensing with a variety of separate rooms and became a 'fun' pub named Sam's Bar in 1990. It was later transformed into an alehouse under its original name

The Kings Arms.

The Wheatsheaf

but after Boddingtons ceased as a pub-owning chain in 1990, it was a gay pub for a while called the Flying Handbag. Ian McCloughlin tells us that the Kings Arms had a great social club which supplied a fantastic buffet every Christmas, where membership was 50p a year and that the landlord and landlady (Jack and Kitty) retired when the pub became the Flying Handbag. The Handbag was demolished in 2007 as part of Blackpool's 'Talbot Gateway' regeneration plan and the site is now part of the new Sainsbury store and car park.

7. Talbot Hotel, Talbot Road (1845–1968)

The Talbot Hotel was built by Thomas Clifton in 1845 on the corner of Talbot Road and Topping Street near the prospective site of the new Talbot Road Station. The hotel was in a Gothic style which featured a facade of small beach pebbles and mullioned windows. It was first occupied by Richard Carter and had a yard and stables for fifty horses. The railway into Talbot Road Station, fronting onto Dickson Road, opened on 29 April 1846. From September 1873 an annual crown green bowling handicap tournament, known as the Derby of the bowling world, was held at the Talbot Hotel on the bowling green enclosed behind the hotel. The hotel was owned and run by the Nickson family between 1856 and 1921. In 1929, when the manager was Harry Platt, the stables had gone and what was now a C&S Brewery hotel had a 'large garage adjoining'. The hotel (seen here in 1964 with Talbot Road Bus Station) was demolished in 1968 and a multistorey office block (Prudential House) was built on the site with shops at ground level. Since 2015, Stillies Showbar with its doorway on Talbot Road (in between Cool Traders), has occupied the basement area of part of the pub site and was previously the Touchdown Tavern and later the Mardis Gras nightclub and Brandy's.

Talbot Hotel

8. Ma Kellys (formerly the Station Hotel), No. 77 Talbot Road (c. 1840–present)

The Station (like the nearby Talbot Hotel) was owned and run by the Nickson family in the 1880s–90s and it advertised in 1899 that it sold 'Bass's and Dutton's Ales'.

In 1901, the first prosecution of its kind (in Blackpool) under the Intoxicating Liquors (Sale to Children) Act (1901) caused interest when the defendant Martha Mathie, of No. 15 Fisher Street, was accused of sending a boy under the age of twelve to the vaults of the Station Hotel with a bottle to be filled with beer. The boy was refused service but a patron of the hotel, a policeman, followed the boy home. Martha pleaded not guilty but as it was a 'first offence', she was fined 2s 6d and costs, or seven days in prison. The Station was completely rebuilt in the 1960s and the pub is now 'Ma Kellys North', owned by Paul Kelly. It is a large busy pub with booth-type seating, extensive cabaret seven nights a week and karaoke sessions.

9. The Imperial (was also Flashmans), Nos 69–71 Talbot Road (pre-1950s–present)

This building has had many identities as a pub over the years and was first licensed as the Imperial Bar. It was Flashmans in the 1990s and became Taboo, a gay venue bar owned by In the Pink Leisure Group, in 2006. It became Tobago and Lucy's@Tobago from around 2010 to 2015, a fun pub with live cabaret. It became the Imperial Bar again in 2015 and is now a single-room Thwaites pub decorated in a 1950s' classic style. There is a small stage at the rear for karaoke at the weekends and a drag queen act on Sundays. It is said there is a ghost upstairs and falling objects and train noises have been heard.

Above: Ma Kellys.

Below: The Imperial.

10. Pepes Bar, No. 94 Talbot Road

A gay-friendly basement bar, thought to have first opened in 1986, Pepes Bar closed for ten years between 2005 and 2015 and reopened in mid-2015.

11. The Victoria (Whittle Springs), No. 50 Talbot Road (1940s–present)

The Victoria is also known (and signed) as the 'Whittle Springs'. While a board inside the pub says that it was the Victoria Restaurant in the 1940s, it is thought to have been known as the Victoria Hotel by the 1930s. It is said that local taxi drivers who parked outside the pub and could see the Whittle Springs mineral counter nicknamed it the 'Whittle' to distinguish it from the Little Vic in Victoria Street. The pub today is a popular small, single-room pub that was owned by Matthew Brown until 1987 then Scottish & Newcastle Brewery until 2008 when they were taken over by Carlsberg and Heineken.

12. Molloy's (formerly the Railway Hotel and later O'Neill's), No. 23 Talbot Road (1840s–present)

The original Railway Hotel, on the corner of Abingdon Street (then Parker Street), is thought to have been built in the late 1840s. The licensee (Nicholas Topping) in the early 1850s advertised that 'a large room attached to the house has been completed and was ready for the accommodation of cheap trips, tea parties, soirees, and as a sale-room'. In 1855, when the adjacent Sacred Heart RC Church was being built, services were held in the vaults of the pub by Revd George Bampton. In 1889 Albert Fisher was the owner. It housed Bogies wine bar for a while in the 1980s and remained the Railway until 1996 (owned by Bass Taverns) when it changed to O'Neill's, an Irish-themed pub, a Mitchells and Butler brand. Since around 2011 it has been named Molloy's and is now owned by the Stonegate Pub Co. Molloy's now comprises a large open area with central bar and has been managed for the last nine years by Stuart Hiley.

The Victoria, otherwise known as Whittle Springs.

Molloy's.

13. Yates's Wine Lodge, Talbot Square (1890s–2009)
The building we all knew as 'Yates' Wine Lodge' in Talbot Square was built as the Talbot Road Arcade and Assembly Rooms and opened in July 1868. The building included Blackpool's first substantive theatre, the Theatre Royal, and from 1880, Blackpool's first free library. In the 1890s Talbot Road Dining Rooms occupied the front and ground floor of the Assembly Rooms and in 1894 the Yates brothers took over Liston's Bar at the rear and opened a wine bar on the Talbot Road side of the building. They bought the whole complex in 1896 and converting the ground floor into Yates's Wine Lodge. It had a long snake-like bar serving sherry and port, there were hogsheads of Australian white and red wine and a separate champagne stall serving champagne on draught at 10*d* a glass. Yates's Wine Lodge suffered a fire on 15 February 2009 destroying the building, which was subsequently demolished. Yates's was not a listed building and one of Blackpool's most prestigious sites remains undeveloped at the date of this book.

14. Nyx Bar, Talbot Square (2014–present)
There were houses on this site in the 1860s, which were later to become shops. In the early 1900s it was Jenkinson's high-class confectioners, run by the Jenkinson sisters and served luncheons and teas daily and had a cast-iron canopy at the front. It was bought by the Lobster Pot Group in 1960 and became the Movenpick restaurant in the 1960s, before becoming Jenkinson's Bar, popularly known as 'Jenks' with its back door onto the Strand and Lucy's Bar downstairs in the old Zurich Room. Rumours opened in 1983 and closed around 2014 with it becoming Nyx Bar.

15. Clifton Arms
See Section 1, Blackpool's Early Days.

16. Counting House, Talbot Square (1992–present)
The Counting House stands on the site of the first bank to be opened in Blackpool by the Preston Banking Co. in 1863 and a Viener's jewellers shop. The bank, on the corner of The Strand and Talbot Square, was reconstructed in 1891 and became the London and Midland Bank. The extension of the

Yates's Wine Lodge.

Midland Bank to encompass the full block between the Promenade and the Strand was completed in June 1956 and was faced with Rainhill Redstone obtained from quarries in Liverpool with a very high standard of workmanship, so that the place where the old and new buildings join can hardly be discerned. The building was transformed by Boddingtons into a pub and opened in September 1992 and is now owned by Greene King. The banking hall with its high ceilings and ornate frieze in the centre, is now the main drinking area. The pub is popular with stag and hen parties.

17. Merrie England, North Pier
The Merrie England bar at the front of North Pier has been a 'show bar' catering for visitors for decades. Joey Blower, comedian and compère, has hosted the show for many years.

Counting House.

Section 5

Central and South Shore

Central and South Shore

1. The Castle
2. Pump & Truncheon
3. Bierkeller
4. The Stanley
5. King Edward VII
6. The George Hotel
7. Uncle Peter Websters
8. The Ardwick
9. Lifeboat Inn
10. Ma Kellys Central
11. MacNaughtons Bar
12. The Foxhall
13. Crazy Scots Sports Bar
14. The Manchester Bar
15. Old Bridge House
16. The Excelsior
17. The New Albert
18. Auctioneer
19. Ma Kellys South
20. Dog and Partridge
21. Royal Oak
22. Yates
23. The Sun Inn
24. The Dutton Arms
25. The Bull
26. The Harold
27. Velvet Coaster
28. Star
29. Burlington Hotel
30. Farmers Arms
31. Dunes Hotel

1. The Castle, Nos 28–32 Central Drive (1939–present)

The Castle Hotel, adjacent to where Central Station used to be, was built in 1939 and its licence (and name) was obtained from the Castle Inn, which was on Market Street before it was demolished in 1939. Nick Moore says it was previously the site of Lawrence Wright's music shop. It was home to Joplin's Piano Bar during the winter months of the 1970s with Roy Rolland at the piano and is now a sports bar.

2. Pump & Truncheon (formerly the Brunswick Hotel), No. 13 Bonny Street (1932–present)

Formerly this was the Brunswick Hotel and was completely rebuilt during 1931–32. It was designed by J. C. Derham and opened on 19 March 1932. The 'handsome exterior' (as described by the *Gazette* of 19 March 1932) comprised terracotta dressings (now mostly painted black) and rustic brick facings with a half-timbered and cement panels above. It then had a public bar, together with a saloon and a snug, with a sliding screen so that in summer the two rooms could form one large room. It was renamed the Pump & Truncheon in the 1980s and had memorabilia from the old Blackpool borough police force. The pub is now a single room with a log fire, darts and pool table, serving a range of craft and cask ales.

3. Bierkeller (also the Huntsman), No. 93 Promenade (1913–present)

The building that became the Huntsman was designed by Tom Lumb and built by Sir Lindsay Parkinson. It included a large café area, hall and shops, and by April 1913 it was known as the White Café. The Central Beach Cinema opened on 17 May 1913 and in December 1914, Redman's Café opened on the first floor. The cinema's owner, Blackpool Cinemas Ltd, went into

The Castle.

Pump & Truncheon.

liquidation and in 1921 the cinema reopened as part of the Trocadero Hotel. In 1935 it became the Ritz. In 1938 it was given a new interior and ground-floor neoclassical façade clad in white faience to the design of Halstead Best and it became the Huntsman Hotel. The basement of the building became a bierkeller and the hotel accommodation on the upper floor was converted into holiday flats.

4. The Stanley, Nos 9–11 Chapel Street (1860s–present)
A beerhouse known as the Stanley Arms has been on the site since the 1860s when Richard Bray was the landlord of the premises at No. 9 Chapel Street. In 1893 it was owned by the executors of James Mercer and the landlord was Edward Bury. It was a Thwaites pub for many years and is now known as The Stanley Bar & Cabaret, with karaoke and live entertainers.

5. King Edward VII, No. 39 Central Drive (1903–present)
The King Edward VII Hotel opened in 1903 and stands on the site of Bonny's Farm (demolished in 1902) one of the oldest lodging houses in Blackpool. It is a large open pub with a central bar. It has retained a few etched windows on the frontage with the 'Marshall and Co. Ales'.

6. The George Hotel, No. 174 Central Drive (at the corner of Ibbison Street; c. 1880–present)
When this area was the separate community of Revoe, the Revoe Inn stood on the site and was owned by Thomas Ball in 1885. The chief constable of Blackpool's report to the Justices sitting in August 1895 states that the licensee of the Revoe Inn Beerhouse was Elizabeth Lingard and the new pub was reconstructed in the last year. The late Alan Stott in his *History of Revoe* says,

> Around 1893 it was demolished for the George Hotel, a great centre for fisticuffs from the unruly element of Ibbison Street. From 1897 it was owned by the Threlfall Brewery Company of Salford. A local described the 'antics' at the George on a weekend night after

The George.

closing as there being 'more action outside the George at weekends than in a Las Vegas on a big fight night.'

Also there was a Boxing Day pub tradition where locals would wear fancy dress and walk down 'the Drive' around Sparrow Park then back to the George. There were meat and beer prizes for the winners.

7. Uncle Peter Webster's, Promenade (c. 1880–present)

Built as the Washington Hotel in the 1880s, a 1921 prospectus issued in respect of the sale of the property describes the pub as 'one of the best accustomed Wine and Beerhouses in the District and is situate in one of the busiest parts of the Promenade'. The two-storey building was completely rebuilt in 1930 and was clad in cream faience. It was later renamed Uncle Peter Websters but the blue lettered panels with 'The Washington' remain intact to the side of the pub and to the rear corner with Foxhall Road, as well as the 1930 date of the new building. The recently renovated pub is now a large, open single-room pub with karaoke, a pool table at the front and a dance floor area at the back. Peter Antony Webster first appeared at the open-air theatre on Central Pier in 1951, playing to 1,000 people (mainly children) twice daily, in the open air and in the theatre if wet. 'Uncle' Peter Webster went on to star in over 5,000 shows, and died at home on Sunday 22 May 2011.

Uncle Peter Webster's.

8. The Ardwick, No. 32 Foxhall Road (1860s–present)

The Ardwick dates from at least the 1860s and in 1866 was owned and run by John Worthington. It was known as the Ardwick and Blackpool Hotel in 1897 when it was occupied by Mrs Dunderdale and had a six-day licence. It was owned by Combrook Brewery in 1902 and in 1932 it underwent an interior refurbishment, which saw the kitchens and pantries moved upstairs to provide more room downstairs and an open lounge. It then had a separate billiards room. The Ardwick is a large pub that runs through to Dale Street at the back. It has a sports area at the front with a pool table and dartboards towards the rear.

9. Lifeboat Inn, No. 58 Foxhall Road (1850s–present)

Thought to date from the 1850s, the Lifeboat Inn was owned by Thomas Jolly in the 1870s and by 1893 it was owned by Deborah Jolly of the Mount Pleasant Hotel, Southport. A sign outside the pub states that the pub was used as a meeting place for the lifeboat men of the *Robert William*, Blackpool's first lifeboat, launched on 14 July 1864. In the 1950s it was a Lion Ales pub. On 13 March 2008, Royal Mail issued special postmarks to celebrate the centenary of the official use of the SOS signal including 'Rescue at Sea – Lifeboat Inn – Blackpool'. It is a local pub with friendly staff, a pool table, karaoke and 'bandeoke'.

10. Ma Kellys Central (formerly the Princess Hotel), No. 62 Foxhall Road (1870s–present)

This site was first occupied by the Princess Hotel and was owned by James Eccles in the 1870s and later by Seed's. It was known as the Princess public house and was owned by Thwaites in

Above: The Ardwick.

Below: Lifeboat Inn.

Below: Ma Kellys Central.

the early 2000s. It became Paul Kelly's first 'Ma Kellys' pub and is a large open pub with a small central stage area for singers and musicians. It caters primarily for the tourist trade.

11. MacNaughtons Sports Bar, Nos 64–66 Foxhall Road (2012–present)
A sign above the door states that MacNaughtons Bar was established in 2012. It has a main bar area with pool table and two small adjoining rooms. There is a wooden decked area with seating facing onto Foxhall Road.

12. The Foxhall, Nos 193–197 Promenade (c. 1830–present)
Foxhall was the first house of any substance in Blackpool and is thought to have been built in around 1670 by Edward Tyldesley, the Squire of Myerscough. The building subsequently fell into disrepair and in 1838 it is known that part of the building was being run as a 'beer shop' and it was later expanded into a public house. In the 1870s it was in part a lodging house owned and occupied by Richard Caton and on 13 October 1895, Sarah Toomey, a cook at the hotel, was found murdered in her room. She was stabbed to death by her jealous husband John; who later drowned himself in the sea off Bispham and they both lie buried in Layton Cemetery. In a 1911 advert for the Foxhall Hotel, R. Seed & Co. state that the harmonic room is 'open daily with free admission and they have the finest billiards in town'. It suffered a fire in 1955. It was sold to C&S in February 1964 and was demolished in December 1990. The current red-brick building opened in July 1991 and is now a 1980s-themed disco bar named Reflex with a restaurant upstairs. It has a central bar with a dance floor, pole dancing, pool table, amusement machines and a raised VIP area.

13. Crazy Scots Bar (formerly Charlie's Bar), No. 45 Tyldesley Road (1970s–present)

Crazy Scots Bar is on the site of the Royal Pavilion Theatre, Blackpool's first purpose-built cinema, opened in 1909. The cinema changed its name a number of times during its life (including to the Plaza Picture Theatre in the 1930s) but reverted to its original name in the 1960s. It was used intermittently as a cinema and live show theatre in the 1970s to around 1993. During the 1970s Charlie's Bar (one of the early 'late' bars) opened beneath the cinema. Crazy Scots Bar, as it is known, is owned by Hamish Howitt and is now two separate bars. Scotties – the Inn Place is a sports bar on the ground floor. Karaoke Kaos is downstairs where Charlie's Bar was situated. The bar also has a covered outside seating area.

14. The Manchester Bar, Nos 231–241 Promenade, Manchester Square

The original building on the Promenade dates from 1845 when it was known as Manchester House. An advert for the sale of the Manchester Hotel, from September, 1846, states that it comprised of three spacious sitting rooms and dining room with bay front, bar, tap room, brewhouse, coach house, stables, ten single bedrooms and five double bedrooms. In the 1860s and 1870s it was named Hemingway's Manchester Hotel after its owner and licensee James Hemingway. The Manchester Hotel was rebuilt by C&S and opened in May 1936 in the modernist art deco style. It was altered in the 1960s and rebuilt in the current red brick in 1996 due to corrosion of the building's steel frame. The pub is now owned by Stonegate and has a large open area which becomes a dancefloor at the weekend with its central V-shaped bar and is primarily popular with holidaymakers. It has a family food bar upstairs with a free children's soft-play area.

The Manchester Hotel's bar.

15. Old Bridge House, No. 124 Lytham Road (1870s–present)

The pub was owned by John Ball in the 1870s, when the landlady was Grace Cartmell, and was rebuilt sometime around 1879. The name of the pub is thought to refer to its proximity to a bridge once over Spen Dyke near to Manchester Square. It was re-modelled in the 1930s and was a Matthew Brown pub. It is now owned by Heineken and has a welcoming bar with a large cabaret bar and lounge at the back with a large screen, pool table and dart boards. It has facilities for pool and darts and fields football teams in the local leagues.

16. The Excelsior, Nos 177–181 Lytham Road (post-1900–present)

It has been said that this was the site of social club for the adjacent Catholic church which became the Excelsior public house. It is a free house with a large open area, a pool table and small stage to the rear. It hosts discos, karaoke, quiz nights and live music.

17. The New Albert, No. 215 Lytham Road (c. 1870–present)

The Albert Hotel was built in around 1870 on the corner of what was then Albert Road before its name changed to Haig Road in 1925. It was owned by the Threlfall Brewery Co. of Salford in 1895 and it was improved in 1930 by creating a large main room where before there was a parlour, lounge snug and domestic quarters. It has been closed at times but has been refurbished and is now a light and airy free house with a large open L-shaped sports bar adorned with an extensive amount of sports memorabilia, a free pool table, three-quarter-sized snooker table, numerous large screen TVs, pool and darts. The pub sponsors local boxers and has regular celebrity guest appearances including Jimmy White (snooker), Eric Bristow (darts) and Sugar Ray Leonard (boxing).

18. Auctioneer, Nos 235–237 Lytham Road (1999–present)

Between the 1930s and 1950s the building was P. Bailey Auctioneers and later was Moor's Market and then a Kwik-Save store. The Auctioneer opened on 14 December 1999 and was Wetherspoon's first pub on the Fylde. The Auctioneer underwent major refurbishment in July 2014 but was put on the market in November 2015. Its customers and locals raised a 2,500 signature petition against its closure. It was sold to Hawthorne Leisure in 2015 and is now a large, open, friendly free house with a large selection of real ales and food. It has a beer garden at the back and seating at the front onto Lytham Road.

19. Ma Kelly's South, Nos 239–241 Lytham Road (2013–present)

The property occupying the Lytham Road/Bagot Street corner site had previously been shops, offices (above), a warehouse and in around 1997 it was FADS wallpaper shop and later Bargains DIY. From around 2002, it was a takeaway. Companies House records for this property show that the Sofa Bed Co. (Blackpool) Ltd and later a hairdressers and beauty treatment company named Pamper Time operated from this location. Ma Kellys South opened as a public house and cabaret bar in 2013. It has the red and black house-style seating and a small stage at the back for live acts and karaoke.

20. Dog & Partridge, No. 265 Lytham Road (1961–present)

The original Dog & Partridge Hotel was built on the north-west corner of Lytham Road and Waterloo Road by Cornelious Bagot and dates from the 1830s. It was owned by Boddington's from 1893. It had a coaching house attached to the rear which was demolished in March 1948. The old pub was taken down in 1961 and the licence and the pub moved to its present site on Lytham Road. It is now owned by Greene King. The pub is accessed from Lytham Road through

Above: The New Albert.

Below: The Auctioneer.

Dog & Partridge.

a small porch into the splendid, high ceilinged, oak-panelled room with the bar at the side. There is a pool table, three-quarter-sized snooker table and rear courtyard area. Hidden away near the back is a leaded-glass window from the old Dog and Partridge.

21. Royal Oak, No. 322 Lytham Road (pre-1850–present)
The Royal Oak dates from before 1850 and by 1893 it was owned by C&S, who rebuilt and reopened it in July 1930. A newspaper article dated 12 July 1930 stated that the new hotel had 'risen out of the ashes of an ancient inn at South Shore'. The elevations to the two-storey hotel were of glazed terracotta and Whinney Hall bricks with cream granite and Westmorland green slates to the roof. The new pub had a large lounge, a central bar leading to a snug and the Oak Room, a public bar and an 'outdoor department'. The main lounge to the high-ceilinged pub is now a large open area with a stage and the pub it has retained the oak fireplace, which was designed by Robert Thompson ('Mouseman'), with its famous hidden carved wooden mice.

22. Yates, Nos 407–411 Promenade (the site of the Britannia Hotel, later the Lion Hotel/Red Lion, 1937–present)
The Britannia Hotel stood on this Promenade site and it is said that its roof timbers were from ships wrecked on the shore. The Britannia Hotel was demolished in 1909 and the site left empty. The Lion opened in July 1937 to an art deco style design by Halstead Best, with red-brick and cream-faience detailing. The ground floor had a saloon, smoke room, lounges with semi-circular bay windows, a public bar and outdoor department. It had a central island bar serving all rooms on the ground floor. On the first floor there was a sea view from the saloon bar and there was

Royal Oak.

a roof garden on the flat roof which could be accessed from the café on the first floor. It was named the Red Lion in the 1980s when it was a Matthew Brown pub but in the 1990s the pub was taken over by Yates and has been much altered. The pub is now Yates and is a large open pub with raised seating areas at the front, two pool tables at the rear and outside seating facing the sea. It has retained the large upstairs room that overlooks the sea and is a family dining room with a party/kids room at the rear.

23. The Sun Inn, No. 88 Bolton Street (1880s–present)
The 1885 Register states that Robert Wilkinson was the occupier of the Rising Sun, which had changed its name by 1887, when its address was then No. 34 Bolton Street. It was owned by C&S by 1893. The current building was built in around 1900 and is visible from the Promenade. The Sun Inn was closed in 2007 but reopened in January 2010. It is a colourful building currently painted in Blackpool FC's tangerine colour, features a single room bar with a pool table and hosts soul and karaoke entertainment nights.

24. The Dutton Arms, South Promenade, Corner of Waterloo Road (late 1931–present)
The site was partly occupied by the Commercial Hotel, which had been licensed from at least 1870. The new Dutton's Arms pub was named after its owners Dutton's Blackburn Brewery Limited, and was built by Joseph Fielding & Sons, Builders of Ashburton Road, Blackpool. It

Above: Yates.

Below: The Sun Inn.

The Dutton Arms.

was set back from the line of Waterloo Road to increase the width of Waterloo Road at its Promenade end from 36 feet wide to 60 feet wide. The new pub opened in October 1931 and had revolving doors to its Promenade and Waterloo Road entrances and a large asphalt forecourt on the Promenade frontage. It had a large lounge, smoke-room and snug with a public bar to the rear with cloakrooms (toilets) in the basement, accessed by stairs leading from the main hall. Its glazed terracotta mullions and doorways and green Westmorland slates to the roof remain, as do three original tiled gable panels with 'DUTTONS ARMS' and two tiled panels with illustrations of a pyramid of casks. It had central heating (in 1931) and the fireplaces were provided by 'Naylors' of Blackpool. It was acquired by Whitbread & Co. Ltd in 1964 and suffered a fire in 2010. It is now a large open area pub with two raised seating areas at the front, a pool area at the back and seating on its Promenade frontage.

25. The Bull (formerly The Bull Inn), No. 17 Waterloo Road (1820s–present)

The pub was named the Bull Inn between 1825 and 1850 and was a low two-storey building. On Wednesday 4 June 1884, in a philanthropic effort by some to advance the moral well-being of the South Shore district, the inn opened as the Coffee Tavern. It applied for a billiards licence in August 1885 and in 1892 the owner was William Hall Hampson. It was owned in 2010 by Enterprise Inns and is now a very busy, small, community pub owned by the Craft Union Pub Co. of Preston. It has a pool table and two teams in the local league and a small enclosed yard area at the side. It is run by landlord John MacKenzie and now sells coffee at 95p per cup.

26. The Harold (formerly Last Orders Inn, the Old Bank Inn, Vogue Café Bar), No. 46 Bond Street (c. 1989–present)

The building on the corner of Bond Street (previously Church Street) and Rawcliffe Street was a London and Midland Bank in the early 1900s. In December 1988, planning permission was

Above: The Bull.

Below: The Harold.

Velvet Coaster.

granted to change the use of the ground floor to a public house with holiday flats above. It was first named the Last Orders Inn, then the Old Bank Inn and then known as Vogue Café Bar. It is a large single-room pub with a corner entrance and high ceiling, raised seating area and pool table.

27. Velvet Coaster, South Promenade (2015–present)
Wetherspoon's Velvet Coaster pub on the Promenade is said to be one the biggest pubs in Britain. It opened in May 2015 and has a glass and steel frontage, three floors and a roof terrace beer garden. The site was formerly occupied by the Lucky Star amusement arcade, made famous in the 2004 BBC comedy musical *Blackpool* starring David Morrissey and David Tennant. The new pub has taken its name from the nearby Blackpool Pleasure Beach ride named the Velvet Coaster, which opened in 1909. The pub is decorated with a selection of vintage Blackpool theatre posters, a huge wickerwork sculpture of a circus strongman and a timeline celebrating Blackpool's history.

28. The Star (formerly the Star Inn, then Apple & Parrot), No. 525 Promenade (1932–present)
As part of the widening of the promenade from South Pier to Starr Gate, C&S agreed with the Corporation in April 1928 to sell or exchange the land on which the Star Inn stood for land nearer and in line with the new promenade. As part of the agreement the Corporation stipulated that expenditure on the new building was not to be less than £12,000 in order to ensure that

the appearance was of the standard the Corporation desired for the new frontage. The new Star Hotel was designed by Halstead Best and opened in May 1932. It had revolving doors leading into the lounge, at the back of which is the big island mahogany bar. There was a saloon bar and a billiard room next to the public bar and a smoke room. The new hotel also included a novel 'kiddies' retreat' where children could be left in safe hands for a while. It was purchased by the Pleasure Beach in 1994 and the glass canopy to the west facing elevations was added by the Blackpool Pleasure Beach Co. in 2003. It changed its name to the Apple and Parrot in 2014 but reopened in 2016 as The Star. It is has a large stage for live music in the main lounge with ornate plasterwork ceilings and rear games room.

29. Burlington Hotel, Lytham Road (formerly the Winmarith Hotel)
A property on this Burlington Road corner site, opposite Arnold School, dates from at least the early 1900s and became the Winmarith Hotel. It is a large pub and is said to have had a casino upstairs in the early 1960s. It was owned by Inntrepreneur/Grand Met and later by Scottish and Newcastle Retail in 1994. It sold Wilsons beer and was owned by Pennine Inns Ltd in 1996 when it changed its name to the Burlington. The Burlington became a John Barras pub but it closed for a while and reopened in July 2016. It is now owned by Greene King and has seating on three levels with a pool table downstairs and outside seating areas.

30. Farmers Arms, No. 570 Lytham Road (1936 to present), formerly Gipsy Tent (c. 1870–c. 1890)
The Gypsy Tent pub is recorded as having a beer and cider licence in 1872 and is included in the August 1885 Register of Licensed Victuallers and Beersellers, when the owner was Ellen Benson of the Queen's Hotel, New Road. Later the original Farmer's Arms stood on the corner

Farmers Arms.

Dunes Hotel.

of Lytham Road and Highfield Road and was owned by Richard Seed & Co. Ltd of Radcliffe. A new pub was designed by F. M. Wilding of Blackpool and opened in May 1936, when the old pub closed. The Lytham Road entrance had a wide hall with a parlour to the right and a smoke room to the left. The saloon bar was behind the parlour and the vaults were accessed from the Highfield Road entrance. It was a Whitbread pub for many years and the rooms opened out into a large open space. It was acquired by Greene King in 2008.

31. Dunes Hotel (the Coffee House Inn), No. 561 Lytham Road (1840s–present)

Located on Lytham Road, at Stony Hill, Marton, it was owned and run by John Pearson in the 1850s to 1880s and its first name was the Coffee House Inn. He held a shooting competition (as did several pubs in the town) in 1854, where the prize was a cheese. In 1888 it was owned by Robert Allen and was purchased by Boddington & Co. in around 1895, who rebuilt it in the 1890s. In the 1980s (and before) it had a full-size snooker table up a flight of stairs towards the back on a mezzanine floor. It has been refurbished and has two rooms, a pool table, an outside seating area and is owned by Greene King.

Section 6

Around Blackpool

There are a few 'new' pub restaurants around Blackpool that are primarily aimed at the food market. These are not detailed below but include: Brewer's Fayre, Yeadon Way; the Swift Hound, Rigby Road; the Outside Inn, at Whitehills Business Park and the Air Balloon on the airport side of Squires Gate Lane.

The Golden Eagle, Warren Drive (1970s–present)

The pub was built in the 1970s and somewhat oddly advertises itself as being in Thornton Cleveleys. It was a Greenhall's pub and was owned by the Spirit Pub Co. from 2006 to 2012. It is managed by Kevin and Tanya and is a large open pub with a several TVs and a games room. It has a Sunday league football team and hosts a quiz night on Tuesdays. It is now owned by Greene King and run as part of their Flaming Grill chain. It holds an annual 'Eagle Fest' organised by Ian Fletcher to raise money for charities where some twenty bands play over the weekend.

The Golden Eagle.

The Albion (later the Old England), No. 226 Red Bank Road (*c.* 1867–present)

The original Albion Hotel was built in around 1867 by William Croft to the front of Town Lane on the Layton Road (now Blackpool Road) site of Richard Hodgson's house and shoemaking shop. In the 1870s the Albion Hotel was owned by Richard Warbrick of Fleetwood. The Old England was built in 1937 in a Tudor style, set back from the road, by the Burtonwood Brewery Co. Ltd. The architect was J. B. Singleton. The brewery held a formal opening ceremony on 25 June 1938 and immediately after the old Albion Hotel was demolished. The central lounge was designed in an 'ancient style' with a 17-foot-high ceiling and walls in half-timbered style with plaster infill. The windows to the central lounge to the south have coats of arms. It was a Cavalier Steak Bar in the 1980s, was then owned by Tetley's, later by Allied Domecq Inns Ltd in 1998 and by Spirit Group in 2003. It reverted to the Albion in 2013 and is now a 'Pizza Kitchen & Bar' pub owned by Mitchells & Butlers.

Xanders Bistro & Bar, Nos 204–206 Red Bank Road (*c.* 2015–present)

Xanders Bistro & Bar was formerly Winstons Bistro & Bar (and Oscars before that) on Red Bank Road near to the police station on the site of what was for a long time a popular chip shop. It is now a sports bar and grill offering live sport, DJ, karaoke and live music at weekends. It has a pool, darts and football team.

The Albion.

Xanders.

Bispham Hotel, Red Bank Road (1935–present)
The Bispham was designed by Francis L. Lumb and opened on 21 December 1935. It had a glazed dome over the main bar and the floors to the saloon bar and ladies' room were rubber. In a 21 December 1935 *Gazette* article it says that 'even a Lancashire clog dancer could not make a noise on these floors'. The Samuel Smith's pub was refurbished in 1985. The Bispham is a 'no frills' pub that serves good beer at a low price, with no TVs, music or karaoke.

The Highlands, No. 206 Queens Promenade (1970s–present)
The property was built as houses on the promenade on the corner of Hesketh Avenue and they were converted into a hotel as the more genteel Bispham developed through the nineteenth century. The Highlands Hotel had a residents' lounge, public bar and residents' sun lounge and was licensed to serve 'intoxicants' to people not consuming substantial meals on the premises in 1978. It had a full interior and exterior refurbishment in 2013. The pub has a large open area with a pool table and pool team. It hosts karaoke on Saturday, quiz nights on Mondays, entertainment on Fridays during summer and there is an outside decked seating area to the front of the pub.

The Squirrel, Bispham Road (1939–present)
The Squirrel Hotel was built by C&S and officially opened on Saturday 6 May 1939. The licence for the Squirrel was transferred from the old Market Hotel, on what is now Corporation Street. The pub was designed as a replica of an old English building with it half-timbered upper section in oak and white plaster infill, two gables and red-tiled roof. It had a central entrance with a revolving door leading to the spacious lounge in light oak, with a limed oak-panelled smoke

Above: The Bispham.

Below: The Highlands.

The Squirrel.

room on the left with a Tudor-style ceiling. There was a public bar in brown oak with chevron patterns and a mahogany and Macassar ebony billiards room predominantly in red and black. It was popular with civil service staff from the large Warbreck complex nearby and was a Crown Carvery with a conservatory at the back for many years. It is now owned by Mitchells and Butlers and run as a Sizzling Pizza, Pub & Carvery, which opened on 29 January 2016. It has a large open lounge leading to the restaurant area, a separate room with a half-sized snooker table and a pool table, a function room and sells cask ales.

Uncle Tom's Cabin, Nos 44–46 Queens Promenade (1907–present)

Uncle Tom's Cabin opened in 1907 on the landward side of Queens Promenade opposite to where the old Uncle Tom's stood. In the 1929 *Blackpool Times Yearbook* the Cabin advertised daily concerts by the Cabin Entertainers and suggested that visitors 'should not fail to see our beautiful tea gardens'. The present building is said to have been owned by the same family since it was built and holds 740 people. The separate rooms on the ground floor have been opened up and one room is given over to a children's adventure play area. The rear garden once had a café and crazy golf and was Peeney's ice-cream parlour. Joanne the landlady has been there eight years. It hosts live music in the summer season and has a pool table and two pool teams. In 2015, when Samuel L. Jackson was filming in Blackpool, he visited the pub, which starred in the 1987 film *Uncle Tom's Cabin*.

The Gynn, Gynn Square (on the site of the Duke of Cambridge Hotel; 1939–present)

The Duke of Cambridge Hotel was built in the 1860s at the northern end of Warbreck Road, (later renamed Dickson Road) and the Promenade. In 1873 it was owned by Matthew Brown and a bowling green was added in around 1889 to the side of the pub. The Duke of Cambridge

Uncle Tom's Cabin.

Hotel was demolished to make way for the Gynn Hotel which was designed by Halstead Best for the Thwaites Brewery and opened on 27 May 1939. The Gynn was built at a cost of approximately £20,000 in a semi-circular style fronting Dickson Road and (in part) Warbreck Hill Road. The saloon, which was once a cocktail bar, is now the Seaview Restaurant facing onto Gynn Square and is open in the evening. The lounge and smoke room have been converted into a large open area with a pool table in the family room part. The bowling green at the side was changed to a children's play area and whilst the black 'soft rubber' surfaced area remains, it is now part of the car park next to a grassed outside seating area.

Devonshire Arms, Devonshire Road (1940 to present)

The Devonshire Arms was built by H. H. Vickers & Son of Whitegate Drive for C&S on the undeveloped land at the corner of Warley Road and Devonshire Road and opened in May 1940. The *Blackpool Gazette* of 4 May 1940 said that 'the new Devonshire Arms adds a touch of architectural distinction to the district' and described it as having a three sided frontage designed by J. B. Singleton with red brick, stone dressings and a Cumberland slate roof provided by Fairclough & Foster of Dover Road, Blackpool. It had a revolving main entrance door leading to a hexagonal hall. The main lounge was (and is still) to the right from the entrance and to the left was the smoke room complete with African walnut woodwork. To the rear there was a large billiard room with an impressive eight-sided dome in the roof. There was also a separate public bar and an off licence, both with their own doors off Warley Road, both now closed. The bar is an oval shape with mahogany woodwork and has an art deco frieze around the top of the inside of the bar. Like many Blackpool pubs it had waiter service and in the 1970s the waiter in the front lounge was Horace, who was a distinctive small man with a white shirt and a dickey

The Devonshire Arms.

bow. It held a hilarious 'jazz billiards' competition on Boxing Day where eccentrically weighted billiard balls were played and the goal was to score exactly seven – score eight at jazz billiards and you lose. Bass Charrington took over the pub in the 1960s and it is now part of Mitchells and Butlers Sizzling Pub chain. The pub's claim to fame is that Lady Gaga visited the pub on Friday 4 December 2009, ahead of her appearance at the Royal Variety Show at the Winter Gardens, as she wanted to have a traditional British meal and she had fish and chips. Dean Leech is the landlord.

Last Orders, No. 80 Sherbourne Road (c. 1950–present)
This was previously the Sherbourne Arms, a Greenhall Whitley pub, thought to have been built in around the 1950s. At that time Sherbourne Road was on the eastern fringe of the bed and breakfast houses of prospering North Shore area and the Sherbourne would predominantly have been a locals pub, as it still is. Brian and Elizabeth Luxton were the licensees in the late 1990s. It became the Last Orders in around 2000 and is now owned by Hawthorne Leisure. William Meechan has been the landlord since 2013. It has a large open lounge area with a pool table and two pool teams, a darts and a dominoes team. It hosts live music on occasions, karaoke (at weekends) and sports TV.

The Victory, Nos 105–107 Caunce Street (c. 1900–present)
The impressive Victory Hotel was built by William Moister when Victory Road was named Moister Road. It is a 'locally listed' building due to its distinctive architecture. It was owned by Thwaites for many years and is a large traditional pub with flats above.

Raikes Hall, Liverpool Road (1870s–present)
Raikes Hall is said to have been built in 1760 by William Butcher and was built as a family home with servant quarters, stables and gardens. In 1802 it was bought by William Hornby of Kirkham and in 1860 the hall became a convent occupied by the Sisters of the Holy Child Jesus until Layton Hill Convent was built. After the convent closed the estate was later sold

Above: Last Orders.

Below: The Victory.

Raikes Hall.

and developed into pleasure gardens. The grounds were used for the Blackpool (Horse) Races and the lands were owned from 1871 by Raikes Hall Park, Gardens and Aquarium Co. Ltd who created the 51-acre Royal Palace Gardens, the first major tourist attraction in Blackpool before the Winter Gardens and Tower were built, with its Indian Lounge, theatre, ballroom, boating lake, monkey house and skating park. Blackpool FC played their games there in 1888–89 before moving to Bloomfield Road. The Royal Palace Gardens closed in 1898 and land was sold for residential development in 1901. Raikes Hall was extended in 1874 and is a Grade II listed building with a Georgian Style exterior uncommon in Blackpool. It was sold by Burnley brewers Massey's to C&S in 1930. With the demise of the Talbot Hotel, Raikes Hall took over hosting the Talbot Trophy, the oldest annual crown green bowling competition in the country. It is a traditional pub with a large lounge and bar area, a beer garden and a privately run bowling green. It has darts and dominoes and pool teams in the local leagues and hosts live bands and karaoke.

Belle Vue, Whitegate Drive (1860s–present)

The original Belle Vue Hotel dates from the 1860s when it was named Albert Hotel before becoming the Belle Vue Strawberry Gardens. The gardens were laid out by John Hodgson, who left the No. 3 in 1862. In 1895 he was granted a licence for singing, music and dancing from 6 a.m. to 11 p.m. It had a bowling green at the side and extensive pleasure gardens, including a bandstand and a dancing platform. In 1913 a new hotel was built just to the south and the site of the original hotel became the Belle Vue Garage (demolished in 2009) and is now a Sainsbury's Local store. The bowling green is now the site of a pay and display car park and the gardens were built upon in the mid-1890s to form the houses on Newcastle Road and Breck Road. It was owned by Bass until the late 1990s and then Six Continents Retail Ltd. It is now part of Mitchells and Butlers Sizzling Pubs chain and is a large open pub with three 'room' areas and outside seating. Robbie Williams filmed part of his video for his single 'Advertising Space' there in October 2005.

Belle Vue.

Boars Head, No. 38 Preston Old Road (1860s–present)

In the 1860s the Boars Head Inn was a beerhouse in Great Marton Village and was run by Cornelius Bagot, the grandfather of the last miller of Little Marton windmill. William Bickerstaffe owned the pub in the 1870s and in the late 1890s it is said that the annual election of Marton's mock mayor began there. The pub was later acquired by Moses Kay who built a four-storey brewery (the Marton Brewery) at the rear and it was owned by Burtonwood Brewery Co. Ltd in 1913.

The old inn, with its whitewashed cobbled walls, was demolished in 1935, together with two adjoining cottages acquired for the purpose of extending the new pub. The new mock-Tudor-style pub with stained-glass windows was designed by J. B. Singleton and opened in April 1936. It had a large open-plan lounge, the vaults and the Fylde Room. It is said that Stan Mortensen used to pop in for a pint after football matches at Bloomfield Road (1941–55 for Blackpool FC) and that his hair was still wet from the shower. Between 1973 and 1989 the landlord was Max Ashworth ('Big Max') who was noted for his wit and gentle manner with his customers. Max is quoted by Roy Edwards in his book *Saddle Up* as saying that his job 'was to play dominoes and curse the customers, my wife did everything else'. It was a Tetley's pub in the 1970s and the excellent Bill (in his blue jacket) was the waiter in the main lounge for many years.

It had an extension at the rear in the mid-1980s for a games room and in the 1990s the managers were Tom and Lesley. It is now a free house serving craft beer and cask ales, managed by Andy Trotter. The internal rooms have been opened out and are serviced from the central bar. While the main lounge remains much as it was when it was first built with old wood and corner booths, there are other tasteful areas, with two pool tables, a large screen TV and drinking areas with large colourful murals of Blackpool in the early 1900s. The row of concrete bollards that were at the front of the Boars on Preston Old Road have gone, and the south-facing frontage is now fenced in and has planted tubs and seating.

Boars Head.

Mere Park Hotel, Preston Old Road (1937–present)
As Blackpool expanded, the rural area of Marton was developed for housing from the 1920s. The art deco flat-topped, two-storey Mere Park Hotel on the corner of Lancaster Road, was designed by J. B. Singleton and was built by C&S. It opened on 21 February 1937. It had a bowling green which was redeveloped in the late 1980s as residential property, now Mere Park Court. George Wilson, ex-Blackpool/Sheffield Wednesday and England captain was licensee at one time. The 'locally listed' pub was bought by Mitchells and Butlers in 2007 and has four room areas and three art deco fireplaces, lighting and fittings. Since around 2010 it is has become part of their Sizzling Pubs chain. Debbie Pink has been the manager since approximately 2007.

The Clarence Hotel, No. 88 Preston New Road (1954–present)
The Clarence Hotel was built and opened in 1954, despite local opposition and a petition with 880 signatures. The pub's name and the licence derived from the old Clarence Hotel at Hounds Hill which was demolished in 1938 to make way for a Marks & Spencer store. The licence was transferred to the Preston New Road site in 1938 before the Second World War, which held up the building of the new pub. The public bar was extended in the late 1970s and the canopies to the windows facing north onto Preston New Road were built in 1986. The Thwaites pub has a long front bar with a games room to the rear.

Toby Carvery (formerly the Clifton Arms), Preston New Road (1820s–2014)
George Westhead was the innkeeper at the Clifton Arms public house in the rural area of Little Marton in 1826 and it was owned by John Talbot Clifton in the 1870s. Situated on the main route into Blackpool, it was rebuilt in the mid-1930s. The Clifton Arms closed on Saturday 12 July 2014 and was reopened by Mitchells and Butlers as a Toby Carvery in late October 2014.

Above: Mere Park Hotel.

Below: The Clarence Hotel.

The Cherry Tree (formerly the Welcome and Railway Inn), No. 321 Vicarage Lane (c. 1870–present)

The Welcome Inn was built on the site of an earlier beerhouse in the early 1870s when the beerhouse keeper was Rebecca Boardman. It was later named the Welcome and Railway Inn and while the Marton line railway (which opened in 1903) ran close by, there was no station in the area. Like many outlying pubs in the Blackpool area it sought attract visitors away from the promenade and it had a singing and dancing licence, bowling green and gardens to the rear. The pub was remodelled after 1938 and was for a long time the only Burtonwood (Warrington) pub in Blackpool. In 1994 the pub was owned by the Victoria Wine Co. Ltd and in 2008 Marstons plc applied for and was granted outline planning permission to provide seven retail units with fifteen residential units above on the site of the Welcome Inn. Clearly the redevelopment of the site did not go forward and the Welcome Inn was bought by Greene King and became a 'Hungry Horse' in 2013 and became the Cherry Tree on 8 August 2013.

Lane Ends, No. 57 Hawes Side Lane (c. 1880 to present)

The Lane Ends Hotel was owned by Matthew Brown in 1885. Harold Monks in his book *Marton: a Century of Change* says that the pub was the haunt of 'Haysiders' almost exclusively in the 1920s and '30s and also (like many pubs of the time) it was the domain of men. The remnants of a large painted sign, 'LANE ENDS HOTEL ... MATTHEW BROWN'S ... STOUT ...' is still faintly visible on the north gable wall of the pub. The pub is now a Star pub, owned by Heineken UK, and has a lounge area with a small stage for live music, DJs and karaoke together with a vaults/games room area with two pool tables. The pub has a bowling team (but no bowling green) and a darts team. There is a grassed garden area to the north side.

The Cherry Tree.

Lane Ends.

Bloomfield Brewhouse (formerly the Bloomfield Hotel), Ansdell Road (1922–present)

The (new) Bloomfield Hotel, owned my C&S, officially opened on 19 March 1922 at the junction of Bloomfield Road and Main Road. A provisional licence had been granted for the new pub at the Blackpool Brewster Sessions in 1915 but due to a rapid rise in building costs at that time, the erection of the building was delayed. The pub opened and closed for a while after 2007 but reopened on Friday 21 August 2015 following its purchase by Dorbiere Pub Group. The pub has been rebranded as the Bloomfield Brewhouse and has a large lounge with games room at the rear with a mural featuring Stanley Matthews. A glass canopy and fenced seating areas have being added to the Bloomfield Road and Ansdell Road sides.

The Waterloo Hotel, Waterloo Road (1901–present)

The Waterloo Hotel was built in a Tudor style and opened in 1901 on the corner of Cow Gap Lane (later Waterloo Road) and Central Drive. It was owned by Magee Marshall & Co Ltd and some of the original etched windows and panes with 'MAGEE', 'MARSHALL' and 'CO'S ALES' survive. Over a rear door, there are two large terracotta panels with shields with oak leaves and the monogram 'M M Co' and 'AD 1901'. The Waterloo Hotel is famous for hosting the 'Waterloo Handicap' which was first held in 1907 and it is considered the home of crown green bowling. In 1907 it had 1,228 entries and in 1919 the first prize was £1,000. Bowling competitions have been regularly filmed and televised from the Waterloo. The high-ceilinged pub has been closed at times but has altered little over the years. It has a large lounge with a central bar and a small stage. The rear seating areas provide an impressive view of the bowling green.

Above: The Bloomfield.

Below: The Waterloo Hotel.

The Highfield, Highfield Road, Marton (1934–present)

The Highfield Hotel was built for C&S in a Georgian style on the corner of Common Edge Road and opened on 12 March 1934. It had a ladies' room, vaults, saloon and billiards rooms with a smoke room served only by waiters and not directly from the bar. It had a 'large clubroom' on the first floor together with five bedroomed living quarters. C&S were taken over by Bass Charrington in the 1960s and whilst the Highfield is now part of Mitchells and Butlers Sizzling Pubs chain, it still has four large stone panels above unused doorways with the C&S' brewery 'livery' initials. The managers of the pub for the last ten years have been Sean and Della Lithgow and the pub now has a large open lounge area together with a sports room area with pool table and large TV screen. The pub hosts live bands, quiz nights, pool and dominoes teams and raises funds for charities.

The Halfway House, St Anne's Road (c. 1835–present)

The Half Way Inn was built in around 1835 by Ezekiel Salthouse and the name 'Half Way' relates to the time when the road from Marton to Lytham continued across what is now Blackpool Airport and the pub was halfway to Lytham. For some twenty years around 1859 Thomas Braithwaite was the landlord, with his wife Jenny. The trustees of Ezekiel's widow's estate sold the Half Way House in May 1867 to Mrs Ellen McLevy, who later sold it in March 1874 to Matthew Brown. Matthew Brown were acquired in 1987 by the Scottish and Newcastle Brewery and the pub is now owned by Enterprise Inns. The pub has large open areas with a central bar and serves real ale. Two original fireplaces remain and there is a pool table, darts area, a three-quarter-sized snooker table, a ladies (Monday league) darts team and pool team. The bowling green to the back of the pub had a new stand in 1980 but a bonfire was lit in the centre of the green in November 2015 and it is now overgrown.

The Highfield.

Sources and Acknowledgements

The authors would like to thank: Ted Lightbown for his support, advice, and images; Tony Sharkey and the staff of the Local History Department at Blackpool Central Library for their assistance and for their permission to reproduce several images; Alan Stott, Norman Cunliffe, Max Ashworth and Andy Trotter; all the landlords, landladies and managers who have helped; the staff of the Lancashire Records Office; CAMRA – Blackpool Fylde & Wyre Branch; Ian Ward, Ray Jackson, Ian Shergold, Terry Moreton, Terry Gorst, Craig Fleming and *Blackpool Evening Gazette*; Chris Aspen; John K. Walton; Blackpool Civic Trust; Bob Dobson; Alex Maitland; Kathleen Eyre; Peter Barnes; Roy Edmonds; John Nicholls; Catherine Rothwell; Steve Palmer; Nick Moore; Layton Friends; Peter Joy; Ian McLoughlin; John Law; Scott MacFarlane; Steve Weigh; Geoff Olsson; Billy Tobin; Gary Courtenay; Barry Sidley; Paul Bonsor; Andy Gent Helen Stout; Chris Wood; Clare Wood; Norma Fowden; Linda Edgar; Robert Muir; W. J. Smith; Richard Johnston; Arthur Lloyd; The Theatres Trust; Rebecca and Rachel Bottomley; and Michelle Wood.

The authors: Allan and Chris.